EVERYDAY
WATERCOLOR
flowers

EVERYDAY
WATERCOLOR
flowers

A MODERN GUIDE TO PAINTING BLOOMS,
LEAVES, AND STEMS STEP BY STEP

JENNA RAINEY

WATSON·GUPTILL
CALIFORNIA | NEW YORK

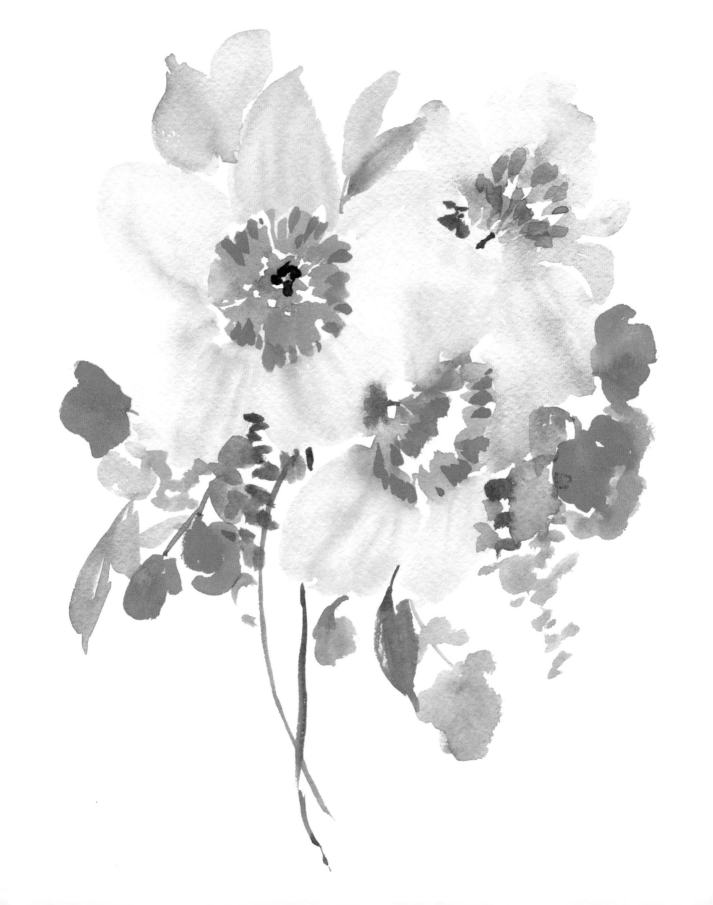

CONTENTS

1 INTRODUCTION

CHAPTER ONE 38
STAR SHAPE

40 CHERRY BLOSSOM
46 ANEMONE
52 CLEMATIS
58 ORCHID

CHAPTER TWO 64
CIRCLE SHAPE

66 SUNFLOWER
72 DAHLIA SCURA
76 RANUNCULUS
82 EDEN ROSE

CHAPTER THREE 84
BELL SHAPE

90 PARROT TULIP
94 ENGLISH BLUEBELL
98 FOXGLOVE
104 PENSTEMON

CHAPTER FOUR 110
BOWL SHAPE

112 CAMELLIA
116 CHRYSANTHEMUM
120 HELLEBORE
126 PEONY

CHAPTER FIVE 132
TRUMPET SHAPE

134 NASTURTIUM
138 STARGAZER LILY
142 MORNING GLORY
148 AGAPANTHUS

CHAPTER SIX 154
COMBINATION

156 SWEET PEA
160 ARUNDINA ORCHID
164 BEARDED IRIS
170 CONEFLOWER OR ECHINACEA FLOWER

177 AFTERWORD: PUTTING IT ALL TOGETHER
180 CONCLUSION
182 ACKNOWLEDGMENTS
183 ABOUT THE AUTHOR
184 INDEX

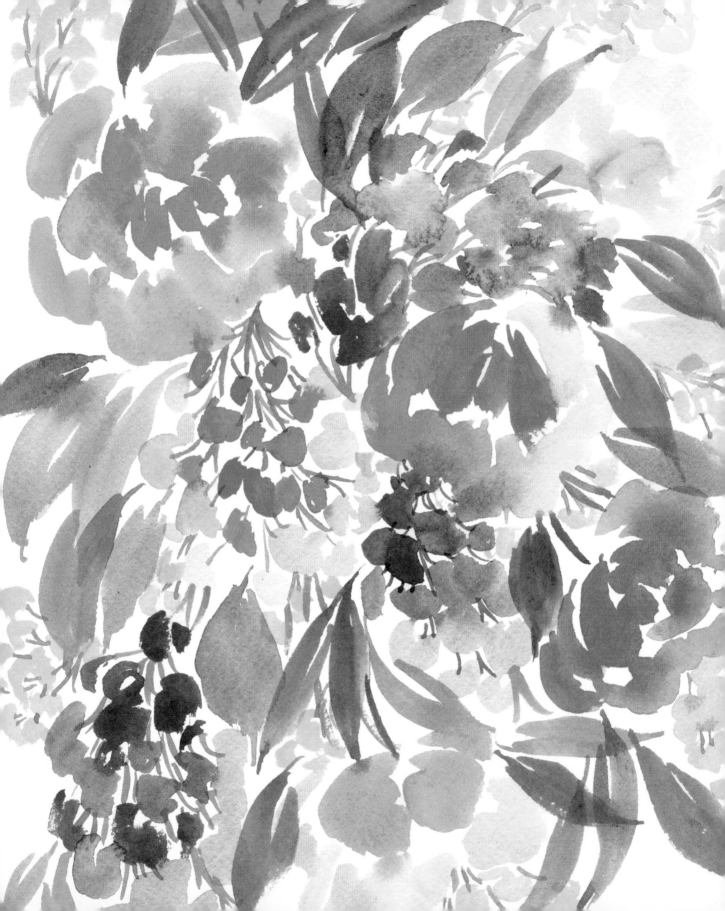

INTRODUCTION

There's nothing more breathtaking than the natural beauty of flowers. The folds and tears in a peony petal or the striking texture in a parrot tulip call for an extra-long look and gasp. Nature has done such an excellent job. A flower can show us how complementary colors work together and how something so delicate can be uniquely powerful at the same time.

For thousands of years, painters and writers have made flowers their subjects, finding in them attributes of beauty, growth, and happiness. I couldn't agree more. Growing up, I was always surrounded by flowers. My mom has an incredible green thumb, and right outside my bedroom window were lilies, jasmine, poppies, chocolate cosmos, and so many varieties of roses that you couldn't count them all if you tried.

I didn't know it at the time, but this childhood experience helped me build familiarity with flowers' shapes and structure. Observing the growth stages of flowers in my mom's garden taught me that a flower in its earliest stages as a bud is spherical, then opens up, petals peeling back, to form a sphere, bowl, or cylinder. A five-petal flower, like a cherry blossom, can be broken down to a star, and viewing a rose from

the side is like looking at a cone or bowl shape. All of this, plus a love for art, made for tons of sketching and painting flowers.

But, for any artist, painting a flower can be intimidating. Grasping the powerful and harmonious relationship between colors while also capturing the delicacy of each petal can be a challenge. One thing that is so important for your practice is to start by interpreting each flower or subject in terms of its basic shapes. Many artists grow impatient with the process of breaking things down first, and the proportions of their subjects suffer. For example, if a rose becomes too oblong, it can look like a tulip, or if one petal in your flower is pointing off in the wrong direction just slightly, it can mess with the whole appearance of your flower. That is why, in this book, I'm here to show you an approachable and quick way of grasping a flower's shape. We are going to be studying flowers with a variety of shapes—star, circle, bell, bowl, trumpet, and combination—all while exploring different techniques to paint in both loose and more realistic styles.

ABOUT THIS BOOK

I'm going to start us off with the technical stuff: the foundations and a few different approaches that are frequently used when painting flowers. We will be using these basic techniques in the chapters that follow. If you're a beginner or need to brush up your skills, you can use this section to warm up before starting the rest of the book.

From there, each chapter will begin with sketching exercises that will help you develop an eye for the basic shape of each flower group. Then we will incorporate the techniques discussed in the first section for specific projects, some painted in a loose style and others in a more realistic style. Each subject and style will require a different set of skills, as well as patience, with the overall goals of training your eye to see shapes, learning to develop depth with a brush, and building confidence.

With practice, you will gain the ability to look at any flower in your yard or neighborhood and break it down into its characteristic shapes,

and the skills to paint it with courage and assurance! The possibilities are endless when you acquire an eye for shapes and nourish muscle memory. I know it's changed the way I see and paint things. Once I really started studying and practicing the foundations of form, perspective, and sketching, my eye and my ability to paint with watercolor were transformed. But, just like anything, practice makes better and mistakes are *good*! I know it's difficult to accept that, especially when you can see so much wonderful artwork on social media. But for every masterpiece an artist creates, there are hundreds of pieces that end up crumpled in the trash. That's what learning and creativity are all about. Making mistakes, embracing them, and making adjustments for next time. And, as you continue to work and paint, you will have little and big "Aha!" moments that will keep you going.

Some of these sections and exercises are going to be trying and difficult. If you've never painted a detailed flower before, it takes time and, most of all, patience. The first time I ever painted a flower in a photorealistic style, I had no idea what I was doing and it took *forever* to complete. But then I painted another one and another and each was better than the previous one—and took less time and was more enjoyable than the last. Some of these intricate flowers will look very challenging at first if you're a beginner, but if you study the sketching exercises, take time to breathe and stretch, and allow yourself to make mistakes, I truly believe you'll be so proud of what you can do!

In the following pages, I'll be setting you up with a list of tools and techniques that are commonly used when painting florals. I will say though that not every artist is the same! Regarding materials and techniques, watercolor is steeped in tradition, which will be touched on, but because I am self-taught, I will also discuss techniques that I've developed over the years of trying, making mistakes, and continuing to paint. This is what has worked for me and what will help you achieve the look and results in the particular styles I will be covering in the pages to come. But feel free to experiment with other materials and techniques as you go; artists form preferences for brands, colors, papers, and methods, and that is okay!

TOOLS OF THE TRADE

Going to an art store to gear up on supplies can be intimidating if you're not sure what you like or what you're looking for . . . so, let me help with that! Here is a list of the supplies I use, along with the reasons why I use them.

PAINT

The strength and quality of your pigments is quite crucial. Let's talk paint.

Quality

Watercolor paint can be purchased either as tubes of paint or as dried color in pans. Both are commonly used. Watercolor pigments come in two grades: professional and student. While the price tag on the student-grade paints may be tempting, the quality of the pigment is not as pure or strong, and you may be frustrated with your results. Student-grade paints are usually grainier, less transparent, and more likely to become muddy than professional-grade pigments. While professional-grade pigments are pricier, the quality is going to give you results that keep you coming back for more. You'll want to practice and learn more when you have better-quality paints to work with. Also, there's no need to purchase a slew of different colors. Start with just a few: primary colors and a couple of others, like green and pink maybe. This will help encourage you to learn more about color mixing—with just a few colors, you can make a whole bunch of secondary and tertiary colors.

I work with tubes of Winsor & Newton Professional Grade watercolor paint that I squeeze into the wells on my palette. I let these colors dry in my palette overnight before I use them. The reason for this is, I don't like to waste paint. I've found that, at the scale I normally paint (usually no larger than 11 x 14 inches), a little bit of paint goes a long way! With dried paint, only a small amount of pigment adheres to your wet brush, while moist paint straight from the tube is more useful in larger-scale

painting when you need to pick up a lot of paint to cover a big area. Something I am asked a lot is why I don't just buy a premade palette or pans of watercolor. It's because I like to have control over the colors in my palette and the size or amount of color in each well. If you're buying professional-grade tubes and letting them dry, this will essentially be the same as buying premade sets of professional-grade watercolor, but you will be able to choose the colors.

Color List (with Key)

Below is a list of colors that I always have in my palette when painting florals, and the abbreviations I use from time to time to refer to them. These pigments are all Winsor & Newton Professional Grade watercolors. I've come to love each of these colors over the years I've been painting with watercolor, but do be adventurous and try out other brands and colors if your heart desires. Every artist is different and can be drawn to different colors. Here are the colors I work with, in the order in which I place them on my palette:

Mars Black (MB)

Scarlet Lake (SL)

Opera Rose (OR)

Cadmium Orange (CO)

Lemon Yellow Deep (LYD)

Yellow Ochre (YO)

Permanent Sap Green (SG)

Prussian Blue (PB)

Phthalo Turquoise (PT)

Cobalt Blue (CB)

Ultramarine Violet (UV)

Burnt Umber (BU)

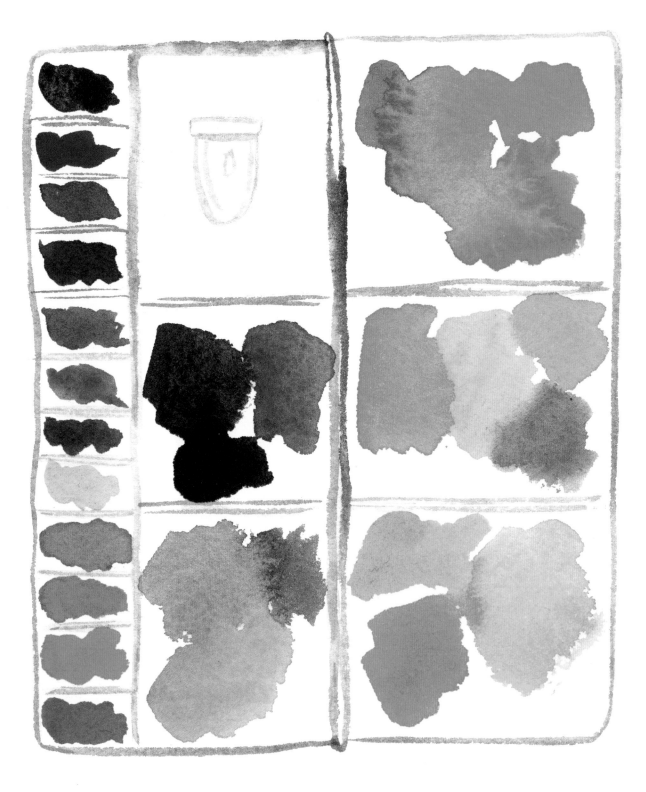

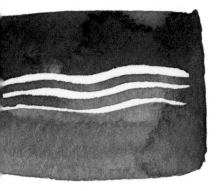

MASKING FLUID

WHITE GOUACHE

SEA SALT

Insider Tips

» Setting up your palette: Squeeze pigments out of the tube into wells in your palette and let the paint dry overnight. How often you'd like to refill each well will determine how much pigment to squeeze out. I prefer filling most of the well with each pigment, so I refill less often. I also like to lay out my colors in the order listed on page 5, following the colors of the rainbow and placing colors that are similar in hue and often mixed together right next to each other. Also, if you follow this layout, you will be keeping your warm colors next to each other in one half, with your cool colors in the other half. I use the same layout for my traveling palette, which is foldable and easily transportable. The left mixing wells are where I mix my cool colors (blues, greens, violets) and the right mixing wells are for warm colors (reds, oranges, red-violets). This will help you keep contrasting colors separated so that you don't get muddy, brown colors in your mixing wells.

» Certain colors, even some professional grade, like Lemon Yellow Deep, can be more grainy than others. This can make it difficult for a color to stay mixed with other pigments, which some watercolorists prefer. The trick to maintaining a smooth wash with these colors is to keep mixing them even when they're on your paper until the area of paint dries!

» Masking fluid is a medium that can be painted onto your paper to preserve highlight or white areas. It covers the highlights and can be peeled up after the paint is dry, leaving bright white underneath!

» Gouache is a thicker, more opaque form of watercolor paint that can be great to use as one of the last steps in your paintings to bring highlights and details forward. I usually have Permanent White Gouache from Winsor & Newton mixed with a little water in a glass jar on hand to use at times when I'm painting more detailed work. My pieces don't always call for it, but a lot of artists love adding this gouache for an extra pop.

» Salt! Sea salt or even regular table salt can create a fun, crazy texture in watercolor. Just sprinkle it up on top of an area of wet paint, let it sit and absorb the wet color, and see what happens! Simply brush the salt off when the paint is dry.

PAPER

Watercolor paper comes in a variety of textures and weights. Made specifically to absorb water, the better watercolor papers are made of cotton. Below is a brief rundown of the options available to you and what I like to use.

Textures/Surfaces

There are three textures of watercolor paper, each yielding a different result.

Hot-pressed paper (HP) has a smooth surface. It is a challenging paper to paint with for beginners, because it causes puddling and calls for more control as there is no toothy texture for the paint and water to hold on to. Some artists' style of painting calls for a smooth surface as it creates different textures and more distinct layers when dry than the other papers.

Cold-pressed paper (CP) is the most commonly used and the type of paper I always work with, specifically Legion Paper's Stonehenge Aqua CP in 140 lb (300 gsm). CP paper has just the right amount of texture to allow for smooth coverage and movement, while not being smooth enough to create puddling like hot-pressed paper.

Rough paper isn't pressed when it is manufactured and therefore has a very bumpy texture. This causes a lot of breaks in brushstrokes, which is preferred by some artists and may be useful for certain subjects.

Thickness/Weight

Watercolor paper also comes in a variety of thicknesses. The thickness of watercolor paper, as with other papers, is measured in weight, either pounds per ream (lb) or grams per square meter (gsm). Watercolor paper ranges from 60 lb (120 gsm)—similar to pages in a journal or mixed-media sketchbook—to 300 lb (600 gsm)—roughly the thickness

of a paper coaster or poster board. I paint on 140 lb (300 gsm) paper. With the amount of water I like to use, it suits exactly what I'm looking for in terms of absorbency; anything thinner would warp a lot easier and not enable color lifting. Lifting color will be explored a lot more throughout this book, but essentially we want our paper to allow us to blot a color to soften it or even take a color off completely, if the color is a non-staining color! The thicker papers, on the other hand, are just not necessary for what I like to do, and are more suited to artists who work very wet or who use multiple layers, or glazes, of color to achieve their effect.

It's important to work with quality paper that meets your expectations and style as an artist, so try out different types. Here are a couple of tips to keep in mind about paper.

Insider Tips

» Watercolor paper that is less than 140 lb (300 gsm) must be stretched (you can find online videos on how to stretch paper) to ensure that it won't warp and buckle once water is added to it.

» Watercolor paper comes in loose sheets, pads, and blocks. A block of paper is glued down on two or more sides, with at least one corner or side left unglued. This ensures that the top sheet stays flat while you paint and prevents warping and buckling! I prefer to paint on blocks; once the piece I'm working on is dry, I will lift it off the block and work on the sheet below it. If you purchase a loose sheet or pad of paper (glued only along one edge; remove a sheet to paint on it), make sure you tape down all four sides with 3M artist's tape. This will keep your paper from buckling once you add water to it.

» Good-quality watercolor paper is made to aid in color lifting. If you're using paper such as Stonehenge Aqua CP or Fabriano CP, you can use a paper towel or a dry brush to lift color off the paper while it's still wet

to lighten the color, getting almost back to the white of the paper, if you made a mistake. So always keep a paper towel handy for this reason.

» Whatever brand, thickness, or surface of watercolor paper you buy, make sure it is 100 percent cotton and acid-free. This will help with absorbency and longevity, and the surface of the paper will stand up to some scrubbing without being damaged.

» Having practice sheets on hand will be helpful, especially if you are a complete beginner! Stonehenge Aqua CP 140 lb (360 gsm) is my preferred paper and, as it is relatively inexpensive, makes great practice paper as well. But if you're still wary of using this paper as practice paper, there's 90 lb watercolor paper out there or other brands, like Strathmore or Canson, that offer cheaper papers. My only hesitation with that is you won't see the same results as on a quality paper and might get frustrated with your practice.

BRUSHES

In my opinion, your brushes are the most important element in your experience with watercolor. The paint you use is definitely a close second, but the quality of your watercolor brushes is crucial to the ease of applying paint to your paper. Brushes can be expensive but if you take good care of them will last a long time. Brushes come in a very wide range of hair types, shapes, and sizes, but I've found that with floral painting, round brushes are where it's at and really all you need.

Shape

When it comes to painting wide and full-coverage washes, flat brushes or wash brushes might be ideal and, for those tiny details, fine-liner brushes would do the trick, but, in my opinion, round brushes are most useful when it comes to painting flowers. The wide belly of the hair comes to a point at the tip of the brush, making them two-in-one

brushes! A round brush can achieve both wide and thin strokes necessary for painting flowers and eliminates the need to buy other brushes.

Hair

Watercolor brushes are made in a wide range of hairs from Kolinsky sable to synthetic, synthetic blends, and more. The hair of your brushes is very important when it comes to holding water, picking up color, flexibility, and durability. A brush should snap back when you release pressure from a wide stroke to create a thin stroke. Kolinsky sable hair is definitely the most coveted and revered among watercolorists. It will last you a lifetime, but these brushes can be incredibly expensive. I've found that Princeton Synthetic Sable brushes from their Heritage 4050 series are very similar to Kolinsky sable brushes, but don't break the bank. When working with round brushes, you don't need a large range of sizes to work with, and for my florals, I use sizes 2, 6, and 16. Three brushes, that's it!

Insider Tips

» If you take care of your brushes, you'll have them for a lifetime. After every use, make sure you wash them thoroughly, but gently. Place your open hand under running water and swirl the brush around in your palm to release pigment and wash the hair of the brush completely. Some artists use brush cleaner or mild detergents to clean their brushes, but I've found that using just water to clean them does the job. Make sure they are always stored flat and with the hair of the brush not splayed out or bent, so that the brush keeps its shape. When working with round brushes, if it's looking blunt, make sure to work the tip of the brush back to a point while it's wet, so that it dries pointed.

» When buying round brushes, make sure the point is nice and clean and isn't blunt or damaged. Most brushes come with plastic covers; hold on to these to use when you travel with your brushes, and while your brush is still

wet put these covers back on. It's also a good idea to look into a brush case—I have a bamboo brush case that's perfect for wrapping up and traveling with.

» When painting, do not leave a brush tip down in your water cup. This creates bad habits and can lead to a sad, damaged brush over time.

ACCESSORIES

In addition to paint, paper, and brushes, you will also need a palette, water containers, and pencils for sketching.

Palette

The palette I work with is called a traveler's palette. Palettes are typically made of ceramic or plastic, because those surfaces are a bit waxlike and resistant to water. When using a palette for the first time, remember that, at first, the water might resist and bubble up, but the more you work with it, the less this will happen. My traveler's palette has twelve wells for individual pigments and five larger wells for color mixing. It also folds up for easy traveling! Do some research on what type of palette you prefer—circle, flat, foldable, etc.—but I've found that these larger, foldable palettes are perfect for what I need.

Water Containers

Water is essential to watercolor, so I always have two cups that are about 5 inches tall filled with tap water. I suggest working with two cups of water. We'll be using water to pick up pigment, to rinse off pigment, and lighten pigment, so we need to make sure the water we're working with isn't dirty or muddy. You want to avoid mixing complementary colors (red and green, orange and blue, yellow and purple) in the same cup because mixing complementary colors always makes brown. Use one cup for cool colors and the other for warm. (Color mixing will be discussed more in the section on color theory that follows.)

Pencils

For some of our practice and the more realistic florals we'll be painting later on, you will need a couple of sketching pencils. I love to use a lighter lead pencil, like HB or 2B, for sketching for my watercolors. Watercolor is transparent, so all of your sketches will need to be super light in order to not show through areas of your painting. Once paint is added on top of pencil, you won't be able to fully erase the pencil! Also, try not to press down on the pencil so hard that you leave an impression on the paper. I mostly use Faber-Castell HB and 2B for all my sketches, but there are many other great brands for these types of art pencils.

COLOR THEORY

Understanding at least the basics of color theory will not only help you mix the colors you want, but will instill confidence in you while you're painting. The color wheel is a helpful resource when trying to understand which combinations can be used to create either harmony or contrast.

At left is a basic color wheel including the three primary colors (red, blue, and yellow), which always form a triad. In between these primary colors are the secondary colors (purple, green, and orange). These colors are a mixture of equal parts of the primaries on either side of them. For example, blue and yellow in equal parts make green! Then, on either side of the secondary colors are tertiary colors (red-violet, blue-violet, blue-green, yellow-green, yellow-orange, and red-orange). Tertiaries are helpful in creating harmony

between colors that sit farther away from each other on the color wheel. For example, blue and red used in a painting create more contrast than blue and blue-violet (a tertiary containing red). So using tertiary colors in a piece that has a lot of complementary or high-contrast colors will help the piece feel more harmonious and connected.

Complementary colors are opposite each other on the color wheel. If we think about opposites in terms of human relationships, it can either be incredible (think peanut butter and jelly) or absolutely awful (think, never-invite-those-two-to-the-same-party people). The same goes for complementary colors—which is why they're called both complementary and contrasting! If red and green, for example are used ineffectively in the same piece, it can be garish and will force people to look away from the piece. With complementary colors, one color in the combination will always be warm and the other cool. When we split the color wheel in half from violet to yellow, from red-violet to yellow are the warm colors and from blue-violet to yellow-green are the cool colors. So if you're ever unsure about which cup of water to rinse off a specific color in, refer back to this color wheel.

In the following chapters, we will be discovering and practicing how to use colors effectively so that they create harmony. This will include talking about intensity and dominance, and how to use color to lead a person's eyes through your piece. But before we jump into painting florals, it's important that we cover the basic techniques and define terms within watercolor. Some of you may already know this material, but a little brushing up never hurt anyone, right?

COLOR MIXING

Implementing color-study exercises into your practice can at times be more important than painting an actual piece for the day. There are some colors that you'd think would be disastrous mixed together, but that may surprise you and turn up a stunning purple or the perfect hue for creating shadows on white flowers. In this section, we're going to practice a few color-mixing exercises that will help you understand colors and the ways you can combine them to produce slight variations, as well as lighter and darker values. With watercolor, you will always be lightening your color with water to make the color more transparent. Adding white paint to watercolor pigment will dilute or mute the quality of the pigment, make it less transparent, and yield a dull color. On the following pages are swatches of all the colors I use with their own value scale. See how many values you have within each color? This is how we're going to create depth in our paintings.

To create a value scale, let's start with the darkest value. Load your brush up with water and swipe off the excess water on the edge of your cup or tap your brush on your paper towel. It's important that your brush is wet enough to pick up pigment, but you never want too much water, as this will create puddles on your paper. Mastering how much water you should or shouldn't have on your brush comes with practice and experience. As a rule of thumb, you never want to have drops of water coming off your brush when painting small- to medium-size strokes. When you're creating big, wide strokes and washes, you'll need more water, but keep in mind this is a trial and error thing that gets easier to grasp over time. Now load the brush with one of the pigments in your palette, then lay this thick, undiluted pigment down on your paper. Now we will begin to gradually lighten the color. Go to your water cup (warm cup if it's a warm color, cool cup if it's a cool color) and swish or flick your brush back and forth in your water cup three or four times. If you are too vigorous with this step, you will remove too much pigment and your color will go from a dark value to a very light value; if you're

too dainty, not enough pigment will be removed and you may not see a change in value at all. So give it a try and make adjustments after you've laid down your next swatch. Repeat until you reach the color's lightest value, which should essentially be the paper color with a slight tint to it. This value-scale exercise is excellent for practicing water control and understanding the depth you have with one color, and is great to do, especially before starting a realistic painting.

Along with value scales, being able to understand combining colors and how to mix up new colors is also essential. Your palette will have mixing areas where you can mix your colors together. In my rectangular travel palette, I prefer to mix my cool colors together in my left mixing wells, then my warm colors in the right mixing wells. For example, if I'm mixing up a red-violet hue, I'll load up my brush with water and red pigment, then bring that pigment over to the right mixing well, since red-violet is a warm color. Then I'll either gradually add blue or purple or both to the puddle of red. If your red, or base, color is bubbling up and doesn't look like much, add water to it to help build the volume up. This will lighten the color, so if you want it to be a deeper value, make sure you're also adding more pigment. What follow are a few color study charts that will help expand your knowledge of color mixing. In general, there is never one shade of green or pink within one flower or subject. Light and shadows will bring out colors within your subject that will, for example, add a yellow tint in some areas and a blue tint in others on the same petal! Look at each color within these wheels to see the tones that are brought out within the different combinations, and refer back to these when you're trying to color match a photograph or real-life subject you're painting from. It's a great exercise to make your own color wheels using your own paints. So create some of your own to have on hand as references.

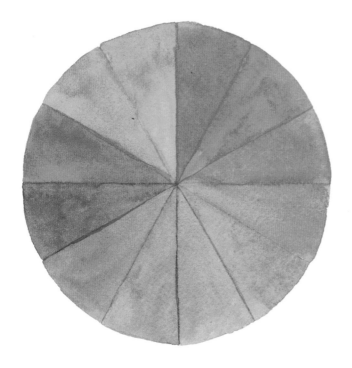

Reds

I have only one red in my palette: Scarlet Lake. But this doesn't mean that it is the only hue of red that I will work with in my paintings. For example, for a more punchy, vibrant red, I'll add a touch of Opera Rose. The neon quality of the Opera Rose helps kick up the orange undertone red of Scarlet Lake a bunch. A touch of Burnt Umber to Scarlet Lake or Opera Rose will help you achieve those more muted and rich tones, and Cadmium Orange with Scarlet Lake will give you a deep coral-red hue.

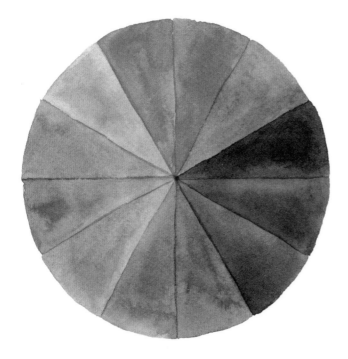

Blues

I use Prussian Blue the most when mixing up blues and will add either Ultramarine Violet or another blue, like Phthalo Turquoise, to it, but there are many beautiful combinations of blues that can be mixed using Cobalt Blue, Phthalo Blue, etc., that can be found in nature. First determine the lightness or darkness (value) of the blue, then whether it will be warmed up a little with purple or stay cool.

Oranges and Yellows

Oranges and yellows are beautiful colors to work with and common colors when it comes to florals, but they can be difficult to work with, especially when painting realistically. For example, when creating a yellow flower such as a daffodil, it's best to paint the shadows of the flower first using midtone warm grays (similar to painting white flowers). Then, once this layer of shadows is dry, the yellow "local" color is added and gradually intensified, where needed, with additional layers of yellow. The same technique used for yellows will be applied for oranges, but deeper shadows in orange flowers can also be achieved by adding browns and reds to the mixture.

Pinks

Pink is such a wonderful floral color. Retain pink's bright intensity by mixing with touches of blues and purples, or mute it by adding Burnt Umber or Yellow Ocher. Do keep in mind that pinks and yellows are grainier pigments. As it will be impossible to get rid of pencil marks after painting with these colors, make sure your sketch is super light.

Purples

The range of purple in flowers is quite stunning. From the more vibrant blue-purples, made with Cobalt Blue and Opera Rose, to deep chocolatey purples, each purple flower has its own unique character.

Browns

When thinking of browns in regard to flowers, it's important to not just think of stems. To achieve deeper, richer color, I'll oftentimes glaze over petals or other areas with a light brown wash. While I have just one brown, Burnt Umber, on my palette, I can mix up a variety of brown hues using primary colors or complementary colors mixed together or by adding yellow to Burnt Umber, black to Burnt Umber, etc.

Blacks

When painting black flowers, it's important that each highlight, midtone, and shadow layer is completely dry before moving on. Blacks have a variety of undertones, which are important when it comes to capturing how the color reflects light. For example, when held in the light, most black flowers are actually a deep brown-purple or -red and each petal's undertone will vary slightly.

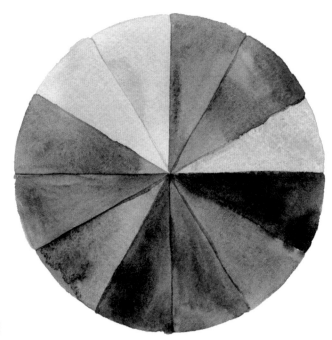

HUE, TONE, SATURATION, AND VALUE

Each color has four main characteristics:

Hue Twelve of the purest forms of color as seen on a tertiary color wheel. These colors do not contain any desaturation or lightness.

Tone Created by adding gray to a hue. Each tone is a more subtle version of each hue.

Saturation/Desaturation or Shade Describes a color's intensity. When the color's value is altered, the saturation decreases and becomes less brilliant. Adding black lessens the saturation of a color or creates its shade.

Value Refers to a color's lightness or darkness. The more water added to the pigment, the lighter or more transparent the hue. The less water added—leaving a thicker, less diluted amount of pigment on the brush—the deeper and richer the value.

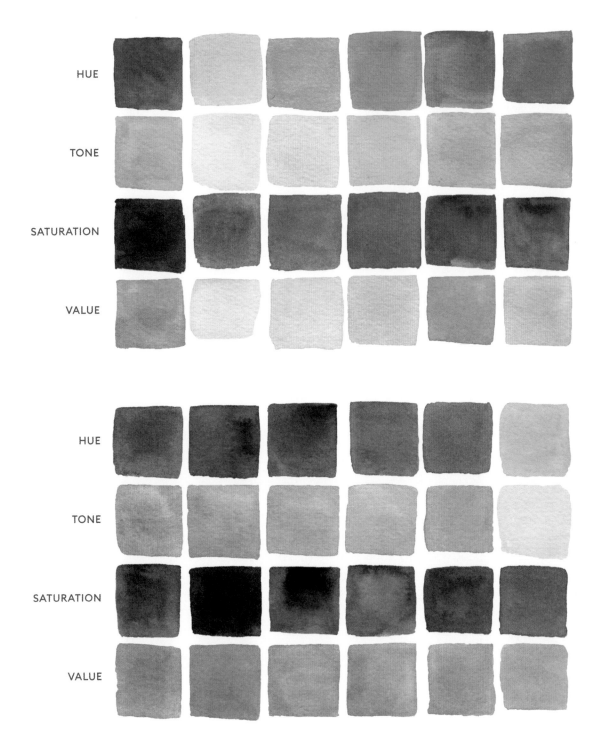

HUE

TONE

SATURATION

VALUE

HUE

TONE

SATURATION

VALUE

THE VALUE SCALE

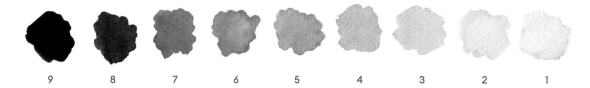

| 9 | 8 | 7 | 6 | 5 | 4 | 3 | 2 | 1 |

While we want highlights to be the lightest versions of a color and shadows the darkest, there are many more shades in between that can help give your paintings even more form and dimension. Create a value scale of your own to use for reference during your journey through this book. Let's use the value scale above as an example.

This scale starts with Winsor & Newton Mars Black at its full intensity at number 9 on the right. For each succeeding swatch, continually lighten the pigment with water just a touch until it reaches number 1 on the left—or pure white paper. You can create a value-scale swatch card by painting this yourself, then cut out the strip of paper and use it as a practical guide for discovering the value number in a photo or real-life subject. To decipher the intensity of each value in a subject (real-life or in a photo) that you're painting from, you can just hold this scale up to it.

Gaining a good understanding of color theory will strengthen your ability to choose harmonious color palettes. As you become more aware of color harmony and the importance of each combination, you'll be able to create more striking and effective pieces. It's important in each piece to strike a balance between unity and stimulation with color and composition. Now let's look at a few arrangements and examples of harmonious palettes that will be helpful to refer to as we make this daily journey together.

Monochromatic One hue, with variations in value/intensity/temperature.

Analogous Any three or four hues next to each other on the color wheel.

In the swatches below, I laid out the range of color, working from top to bottom, by starting with two primary colors (in the left-hand example) and with Winsor & Newton Opera Rose and yellow (in the right-hand example), and gradually adding little bits at a time of Winsor & Newton Lemon Yellow Deep to Scarlet Lake or Opera Rose. This shows the subtle change in hue from one pure color to the next: in the left grid, red to yellow; in the right grid, pink to yellow. The range between the columns shows the alteration of value or lightening of each color, left to right, by gradually adding more water to the mixture.

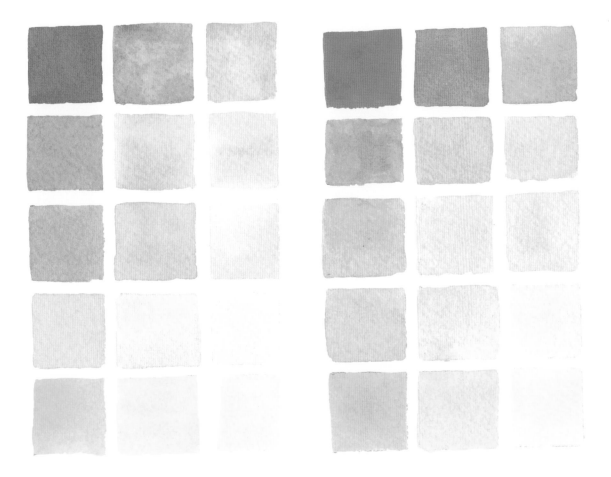

Complementary Any two hues opposite each other on the color wheel.

Complementary colors deliver the highest amount of contrast and can be pretty straining to look at if used improperly. To create more harmony and subtlety, try combining a palette, like in the example below. The two complementary colors are blue and orange. Note the range of blues with a softer value, helping create balance and a break for the eyes. Yellow is also a great color for this palette; it is mixed with both the blue and the orange, helping to merge the two opposing/contrasting complementary colors a bit more.

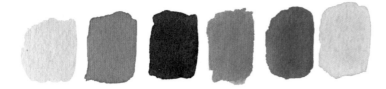

Split-complementary Any primary, secondary, or tertiary hue, plus the two colors on either side of its complement.

An example would be red, plus the two hues on either side of its complement (green): yellow-green and blue-green. Similar to the blue-orange swatches, the palette below contains blended colors that help soften and merge the range between the more contrasting colors. Split-complementary palettes aren't as high contrast as pure complementary colors, but they can still be off-putting. In this example, the hue on the far left is a violet, bringing in hints of blue from the blue-green end of the palette.

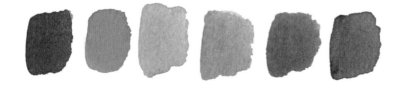

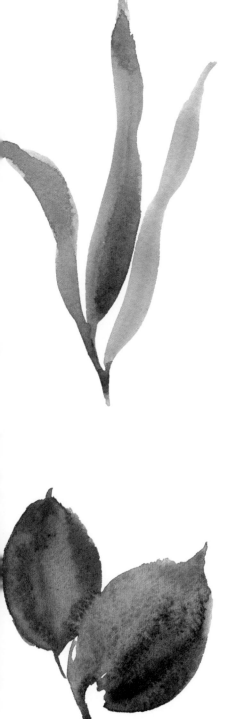

COMPOSITION

When painting most subjects, I prefer referencing the real thing. If I can't get my hands on a particular flower, then I print out a photograph of that flower. Look at the colors and shadows, the veining details in the petals and leaves, and the overall structure of how the flower grows. How does the stem twist and turn, how do the stems branch out? Close observation will help you keep the composition well balanced and the structure true to life whether painting from a photo or real life. Following are a few key components to composition that are helpful to keep in mind with any style of painting.

Balance Creating balance within a sketch or painting is something every artist must learn. If a piece doesn't create balance, the eye will not know where to land, causing strain. Create balance by following the Rule of Thirds, which is a grid system that shows the best placement for elements. To use the Rule of Thirds, imagine a grid of two equally spaced horizontal and vertical lines placed over your composition. Where horizontal and vertical lines intersect on that grid are going to be the most interesting spots for focal points and areas of contrast. In the illustration on page 26, a sprig of nasturtium has three main elements or larger florals that land in three different segments in the piece. This helps guide the eye through the composition. Avoid grouping all the main elements of your piece together. Tip: To avoid perfect symmetry, create movement by grouping the main elements or features in odd numbers.

Position Positioning your subject in the center of your composition causes the eye to land on that target and stop moving into other areas of the composition. This should be avoided. To keep the eye moving throughout the composition, try different angles and arrangements for your piece by placing your main focal points off center and in a way that creates a *Z* or *S* for the eye to follow. Take a step back from your sketch or painting and trace the overall structure or shape of the painting with an imaginary line. Is the line straight and rigid? Or does it meander and move through the space? The goal of composition is to create an *S* curve or zigzag across your paper that leads your eye from element to element with no roadblocks.

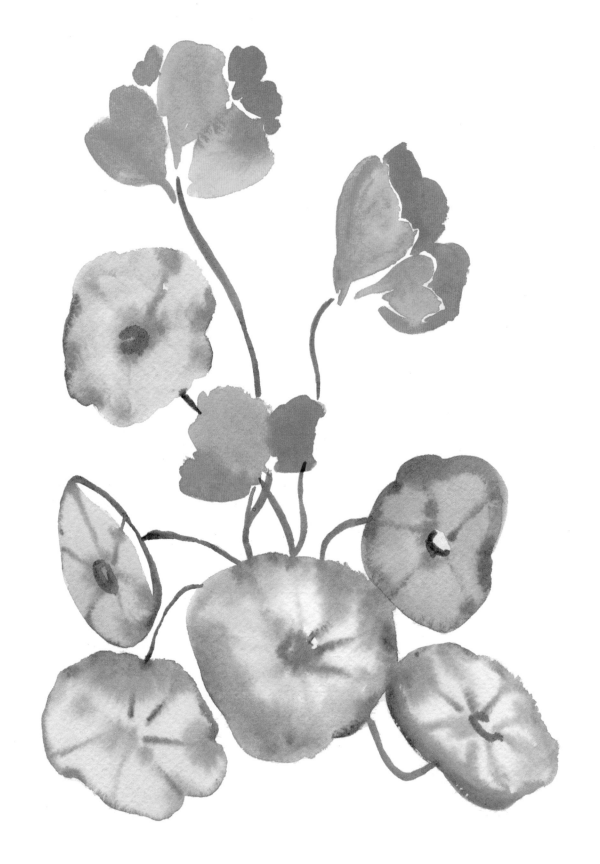

Negative space The space around your subjects is just as important as the space you're painting. These shapes should create just as much movement, balance, and interest to help support the subjects they surround.

Throughout your sketching and painting process, it's important to pull back and take a gander at your composition and assess its strengths and weaknesses before you've gone too far to correct it.

SKETCHING

Understanding the basics of sketching will greatly improve your watercolors as well as give you more confidence in approaching your subject.

SHAPE

We're going to examine the six main shapes of florals by practicing each shape with both loose- and realistic-style florals. Each flower you paint will be made of one or more of these basic shapes. Most of the time, I do not sketch before I paint a loose-style piece, but practicing the basics of sketching from shapes will wildly transform the way you see subjects and paint them, in both loose and realistic styles. For our realistic-style paintings, we will be sketching the contour, or outline. It's important to have patience when sketching this way and to continually refer to a photo or real-life subject to make sure your shapes are accurate.

Here are some examples of shapes we will cover!

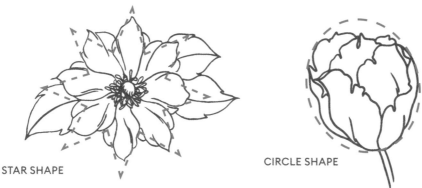

STAR SHAPE

CIRCLE SHAPE

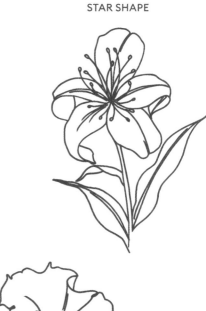

STAR SHAPE

CIRCLE SHAPE

In the chapters ahead, we will be covering star- circle- bell- bowl- trumpet- and combination-shape flowers. Perspective will determine the shape of your flower. Flowers, when viewed from a different perspective, can take on a different shape. For example, a cherry blossom viewed straight on, where you see the stamen, is in the shape of a star, but if held up at eye level, it becomes a cup or bowl shape. The opening of a trumpet-shaped flower seen head-on is circular, but from the side the throat of the flower opens into a trumpet shape.

It's important to have reference materials when painting and sketching flowers. If you're not particularly comfortable with sketching, you can practice by printing out a photograph and lightly tracing it onto a sheet of watercolor paper using a lightbox, or, if you don't have one, by taping the photograph to a window. While this is not my preferred method of sketching, it is definitely a quicker and easier way to get an accurate sketch before you paint! I typically don't sketch before I paint loose florals, but if you're wanting to, don't worry about making it hyper-realistic. Keep the sketch loose as well, kind of like guidelines for your painting. Freehand sketches can have irregularities to them, which provides a certain look, so play with a few different styles throughout your practice.

Curves, Bends, and Foreshortening

In botanical drawing and painting, bends and folds in petals and leaves can be difficult for some to achieve and understand. When looking at a photograph or real-life subject, I look at each element and literally try to focus on pulling out which way the leaf is curving—is it a *C* or an *S* curve? If it only bends one time, it's a *C* curve; an *S* curve will bend twice. Below, I have a few examples that will help you visually understand the flow of curves and bends and how to accomplish them in your pieces.

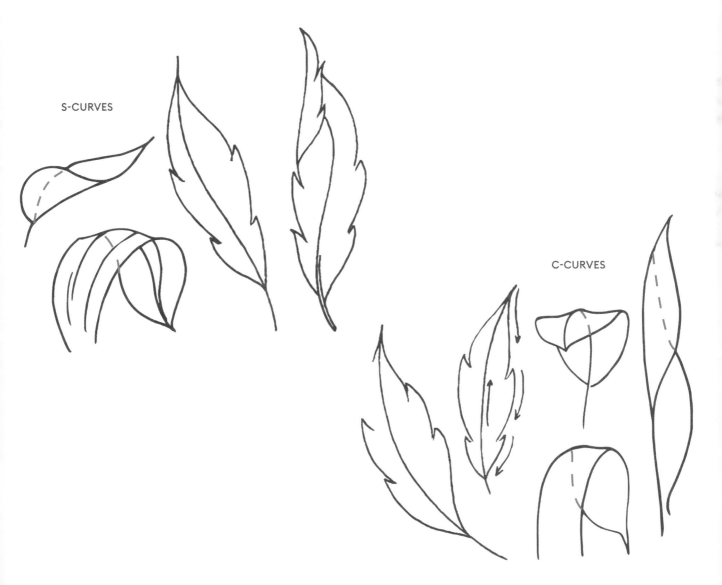

S-CURVES

C-CURVES

TONAL SKETCHING

When painting something for the first time, I often like to study the subject by creating a tonal sketch. *Tone* refers to the scale of light and dark values within a subject. When approaching a subject for a tonal sketch, simply observe how the light is hitting the subject. How does the light affect the form and depth, and where are your highlights, midtones, and shadows? Start by using a light sketching pencil (I use an HB pencil), and lightly pencil in the contour or outline of your subject. From here, work your way through shadows to the midtones, then lessen the pressure on your pencil for highlights following the curve of your subject. For example, the cylinder below is a curved surface. The deepest shadows are on the ends of the form and taper off and get lighter as the shape curves and reaches the center where there's a white highlight. If the shading details were straight lines, this would look awkward and make the cylinder appear flat. The same is true when you're adding shadow details to petals, leaves, etc. Most of the time, floral subjects will have a curve or bend to them, and the shadow lines and details should mimic that curve. Sketching and shading cylindrical forms is great practice for understanding how petals curve and where shadows and highlights should go and will enhance your watercolors.

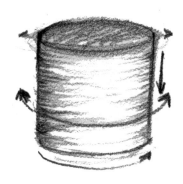

THE ANATOMY OF THE FLOWER

Throughout this book, I will be referencing anatomical parts of each flower. Some of these parts may be unfamiliar, so make sure to study and reference this anatomical painting below when needed.

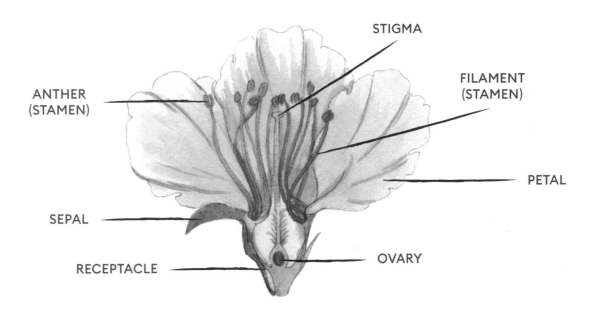

STIGMA

FILAMENT
(STAMEN)

ANTHER
(STAMEN)

PETAL

SEPAL

OVARY

RECEPTACLE

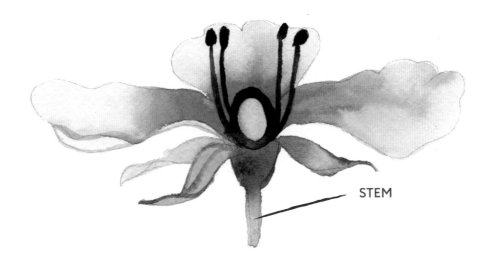

STEM

TECHNIQUES

If you're anything like me, you're probably tempted to skip over the "technique" section of the book and just get straight to painting. *Don't do it!* Because we will be painting in both a loose style and realistic style for florals later on, it's important that we study the technical stuff first in order to understand how to control pigment and water for both styles.

WET-ON-WET

Wet-on-wet is when either wet pigment or just water are used to touch another area of wet pigment or water. This is the technique I use most often in both loose and realistic styles of painting and will be discussed in this book quite a bit. Wet-on-wet technique can be difficult to perfect. A lot of beginning watercolorists struggle with water control: too much water will dilute your colors or prevent them from blending or bursting. On the other hand, if you use too little water, you get hard edges and lines and the paint won't move. It's worth practicing though because when the right amount of water is used, magic happens! The pigment will burst and spread and create a soft, diffused edge perfect for blending, shading, creating texture, and many more effects we'll be practicing in this book.

WET-ON-DRY

Wet-on-dry means wet paint applied to dry paper. This technique is used to create depth with layers. Most of the time in watercolor you will be layering from light to dark, building up color, pattern, and texture. This technique will be used more for our realistic paintings and will help us practice patience as we wait for each layer to completely dry before adding the next. Realistic-style paintings are time-consuming and require a stick-with-it mentality.

CREATING TEXTURES

Watercolor itself has no texture. But some fun textures can be created using supplies and materials you may not think of.

Color Lifting

Color can be lifted, while it is still wet, with a wide array of materials. This technique is generally used to either create texture or lighten areas to create a stronger highlight. Below are a few methods and tools used to lift color.

Dabbing For a softer lift of color, a dry brush, Q-tip, or paper towel is perfect to get the job done. Always have one of these on hand while you're painting, so if you overdo an area with too much dark, you can lift it up while it's still wet!

Highlighting Most highlights are created with light pigments and done while painting, but after a piece is finished, I will occasionally add in tiny spots or veins with white gouache. Gouache is an opaque form of watercolor and is perfect for creating a small punch of bright white in areas that call for it, as in this bearded iris.

Scratching For sharp highlights, an X-Acto knife or toothpick can be used to scratch out thin, tiny highlights.

HANDLING A BRUSH

You have some beautiful brushes to work with, but now what do you do? Let's talk about some foundational brush holds and techniques before we start painting.

Vertical Hold For fine lines and details, hold your brush upright. The more pressure you apply to the brush, the thicker your lines will be. Keep your hand steady by resting the outside of your hand and forearm on the paper.

Slanted Hold Hold your brush on its side and use the belly of the brush for creating washes and wider strokes. Always steady your hand by using the table and paper for support.

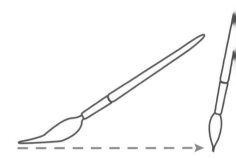

COMPOUND STROKES

Before I get into defining compound strokes, let's cover some fundamental curves first. Throughout this book, I'll be referring to *C* and *S* curves. Both are essential to sketching and painting. A *C* curve is a curve or line that arches one time. Looks like a *C*! While an *S* curve has two arches, or curves, making it look like the letter *S*. Sounds basic, right? Well, sketching and drawing can and should be looked at much more simply. The compound stroke examples at right, and in the chapters to come, will help you to simplify, which will, in turn, help you build muscle memory and skills for painting.

A compound stroke is created by applying both a slanted and vertical hold within one stroke. This is how most of my leaves are created when I'm painting in a loose style, so this is an important stroke to practice. It's harder than it looks, so spend some time on this one. Start with a slanted hold on your brush and make sure the handle of your brush is pointing in the direction you will be painting this stroke. Apply pressure to your brush so that the hair fans out and you're able to obtain a large sweep of color. As you pull your brush along, begin releasing pressure

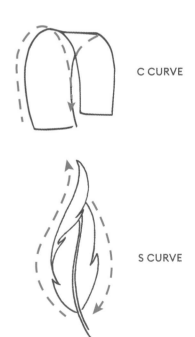

C CURVE

S CURVE

and gradually angling your brush to a vertical hold. You should see a stroke that starts wide and gradually comes to a point. You can extend this stroke for a longer leaf, like tulip leaves, or make them shorter for rose leaves.

LEAF SHAPES

Practice the same type of hold and stroke in a variety of combinations and lengths in order to achieve these shapes!

The Pin Shape

This leaf shape is perfect for tulips or peonies. Its longer belly emulates these florals perfectly and you don't even need to pick up your brush! Using a vertical hold with a size 6 brush, apply little to no pressure for a thin base or line to begin the leaf. Apply pressure so that your brush fans out, and drag your brush up in a C curve to form the belly of the leaf. At the tip, release again for a thin tip! No pressure to pressure to releasing pressure! The first leaf in the pair below is with just very light pressure, while in the second I'm applying a lot more pressure through the belly of the leaf.

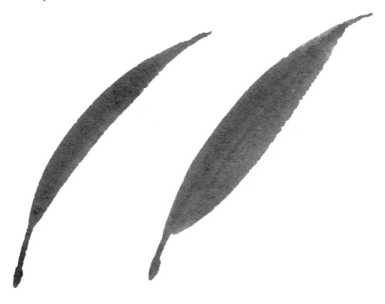

The Eye Shape

I paint this particular leaf shape a ton. Unlike the pin shape, there are two sides to it and the belly is shorter. We'll be using the same three motions, going from no pressure to pressure for the belly, then releasing pressure, but for a shorter length, and then we'll add another side to make the leaf fatter and eye shaped! In the first leaf below I've started both sides of the leaf at the exact same spot, so there is no gap. For the second, I've started a little to the side to leave a gap, which kind of looks like a highlight, and is a fun little detail!

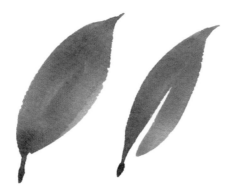

The Heart Shape

Apply the same strokes as for the eye-shaped leaf, but add a lot more pressure in the middle so that the belly of the leaf comes out wider and creates a heart shape!

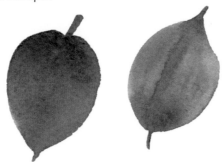

The Oval Shape

Same idea as the heart-shaped leaf, but instead of dragging out a thin stroke for the tip of the leaf, just lift your brush at the end once you've met the middle of the leaf.

A Note about Tone Now that you've practiced a few different leaf shapes, keep in mind that the mood, or palette, of a piece can be altered ever so slightly and illustrate different species of leaves as well. In the oval leaf above, I've used only the color Permanent Sap Green, with varying amounts of water to affect the value or lightness and darkness, but if you look at the leaf below, the tone is much more muted and earthy. Add a touch of Burnt Umber or green's complement, red (Scarlet Lake), to make the color smokier and more muted looking!

STAR SHAPE
CHAPTER ONE

Now that we've covered all the technical stuff, let's get to the fun part and start painting! To begin, we're going to dissect star-shaped flowers in both a loose and realistic style. Each flower will use techniques discussed in the introduction, along with different types of brushstrokes for different shapes of petals, leaves, and so on.

To kick things off, let's start with a simple breakdown and sketch of a star-shaped flower. Despite slight differences among the flowers—like petal shape and size, stamen shape and size—the proportions and the dimensions of star-shaped flowers are all the same.

Using your drawing pencil, lightly sketch a star on some practice paper. Now we're going to add petals around each arm of the star.

The star serves as a guide for where each petal should go in order for the flower to feel correctly proportioned. With your pencil, starting at the base of each arm where it meets the pentagon shape in the middle, pull out an *S* curve and loop over and around each arm with this petal shape. Use an *S* curve to narrow the petal as it gets closer to the center of the flower, to point toward the sepal or center of the flower, like the arms of a star would point back to center! Practice these two steps over and over, and start incorporating texture and folds with each petal.

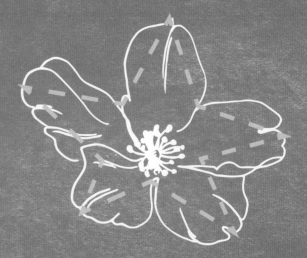

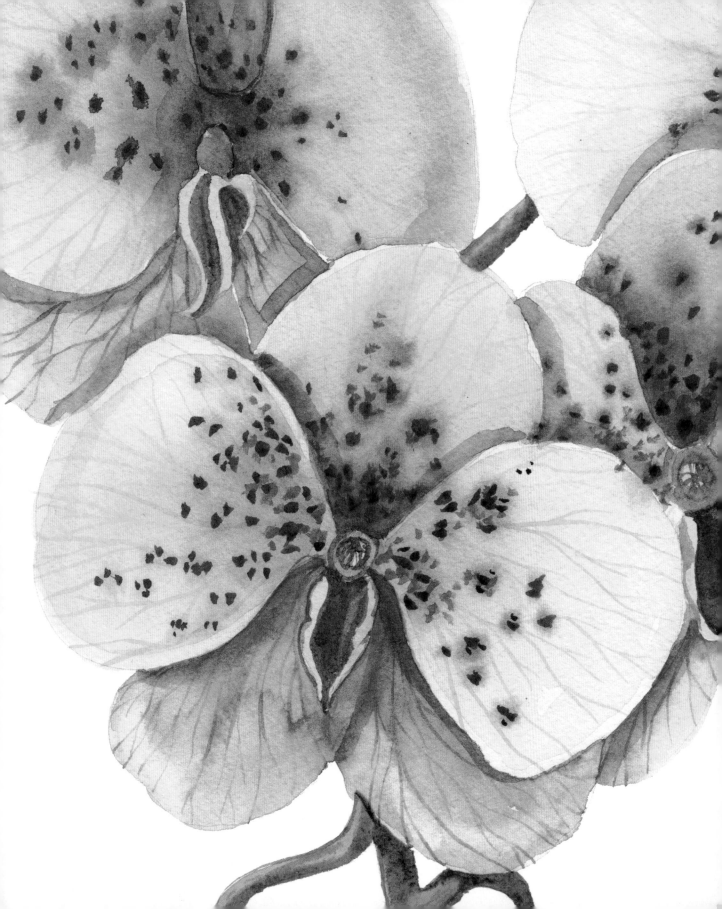

CHERRY BLOSSOM
LOOSE STYLE

Cherry trees in full bloom. There's absolutely nothing like seeing this in person. It's always been a dream of mine to experience Cherry Blossom season in Japan: the explosion of soft pink, with delicate petals coating the floor below the branches, and hundreds and hundreds of blooms tucked in and around each branch on the tree. I mean, come on. That sounds breathtaking, right? With this painting exercise, we're going to work to capture and emulate the softness and delicacy of a branch of cherry blossoms. Watercolor lends itself so well to this style and type of flower.

Before we get started, we're going to need to mix up two or three variations of hues and values of pinks. We'll use one hue per flower that we paint, but multiple values to show detail and dimension. The extra hue varieties (for example, just Opera Rose for one, then maybe Opera Rose and Lemon Yellow Deep for another) will be for other flowers on the stem we paint later. If you're anything like me, I sometimes will skim through or even skip parts of a book's introduction. If you did this and you missed the section on color mixing, you may want to read through it before we start this painting, or any painting! Color mixing is super important and gets talked about *a lot*. Reference the color wheels in the introduction for the specific pinks and greens and other colors used in these paintings. Even if you decide to come up with your own color mixes, the color wheels will help you find the right combination.

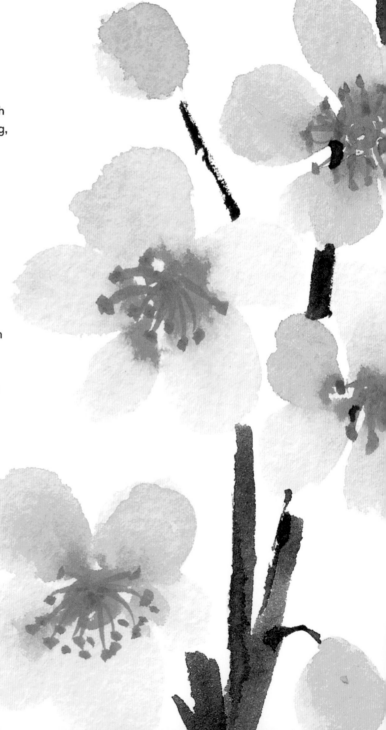

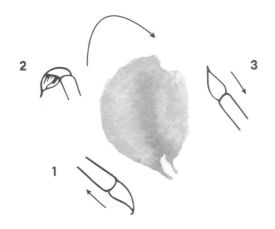

TEARDROP PETALS
STEP ONE

Once you have these pink hues mixed up, it's time to start painting some petals. With a size 6 round brush, and a light value of Opera Rose, make upside-down teardrop shapes: With the tip of the brush pointing toward the center of the flower (or star), press down on the brush so that the belly touches the paper. Do this two or three times for each petal. Make sure you have a decent amount of water on your brush for these petals because in the next step we'll be working wet-on-wet.

WET-ON-WET THAT STAR
STEP TWO

Once you've completed the base hue for all the petals on one flower, go back to your palette and add more pigment to your brush to darken it. For example, if your first layer is just a light Opera Rose hue, then go directly back to Opera Rose in your palette, and load up with a touch more for a darker value. Then, using the tip of your size 6 brush, go to the base of each petal (where it attaches to the center), and punch in this darker hue by touching the tip of your brush to the paper. If your petals are still wet, this color will diffuse into the light pink and create a soft, wonderful gradation of color. If it isn't spreading, you didn't use enough water in the first step, or you took too long and the paper dried. So keep this in mind for next time! It's okay for this to happen in your painting every once in a while, and it creates a different look, but keep in mind that wet-on-wet painting requires quick decisions.

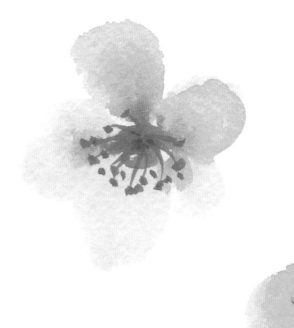

Once you've completed one flower, repeat steps one and two a few more times and add some cherry blossom buds! To make buds, repeat step one, but with just one petal. Looks like a bud, doesn't it?

When adding your additional flowers and buds, think about the overall composition of this piece. We're painting a branch of cherry blossoms. Since the branch isn't there yet, make sure to leave enough space in areas between the flowers where you can have the branch show through. The flowers should dance around the branch to create movement. In general, it looks best to have clusters of flowers in threes or odd numbers. If there's an even number of flowers, or lots of sets of two flowers, people's eyes will land right on those pairs and want to look for more things to pair up. You want to create constant movement and flow, so an odd number will keep them looking.

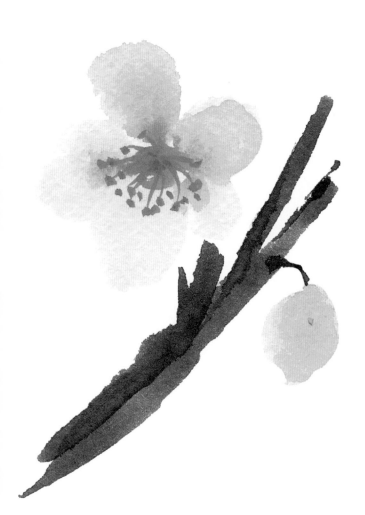

THE BRANCH
STEP THREE

In a separate dish or mixing well in your palette, for your main branch hue, bring in a lot of Burnt Umber and add just a touch of Mars Black to it to make it smokier and darker. Now, pull out a bit of the color, and add a bit more Mars Black to make a darker shade. The darker hue will be the shadow value for your branch.

Now that your branch colors are all mixed up, load up your size 6 brush with the lighter hue (Burnt Umber with a smidgen of Mars Black mix). Before painting your stem, look at the flow of your flowers. For my piece, I've noticed that the flowers start tapering off and becoming buds or more sparse on the right side, while the left side is fuller. I'd like to reflect this with the stem as well. Starting on the right side (or left side if you've done the opposite), use the belly of your size 6 brush to paint a wide stroke. I've brought my brushstroke across in a straight line up to my first flower—a branch that curves too much can look a little funky. From here, paint gradually thinner lines going behind and weaving around flowers until you get to the end of the flowers. When painting in these branches, it's crucial to think of how a flower grows. Each petal is pointing back to the stamen, which we'll be painting in this next step, and is connected to or growing out of a branch. Make sure your branches and flowers make sense together and the branch is pointing toward the stamen of the flower it's connected to. Finish off the branch with a thin edge or tip, using the tip of your size 6 brush. Then darken the base and some of the shadow edge of each branch using your darker Burnt Umber hue. Adding this darker value will suggest the branch's roundness. Just remember, this should be done on the same side of every sprig to show shadow.

STAMEN
STEP FOUR

The stamen of a flower is composed of the filament and anther, or eyelashes and pollen as I lovingly like to refer to them. This is usually the last step when I paint loose-style florals, and really makes a flower pop! For this piece, I think a deeper Opera Rose with a touch of Scarlet Lake mixture for the stamen would be so lovely. There are a few different varieties of cherry blossoms, and with that comes a different variety of petal colors and stamen colors, including this deeper pink stamen color.

With a size 2 brush, load up with a deeper, thicker value of Opera Rose and Scarlet Lake, and using the tip of your brush, paint the filaments and add small dots to represent the anthers. Make sure these elements all pull out of the center point on each flower and aren't just straight lines. C curves look best!

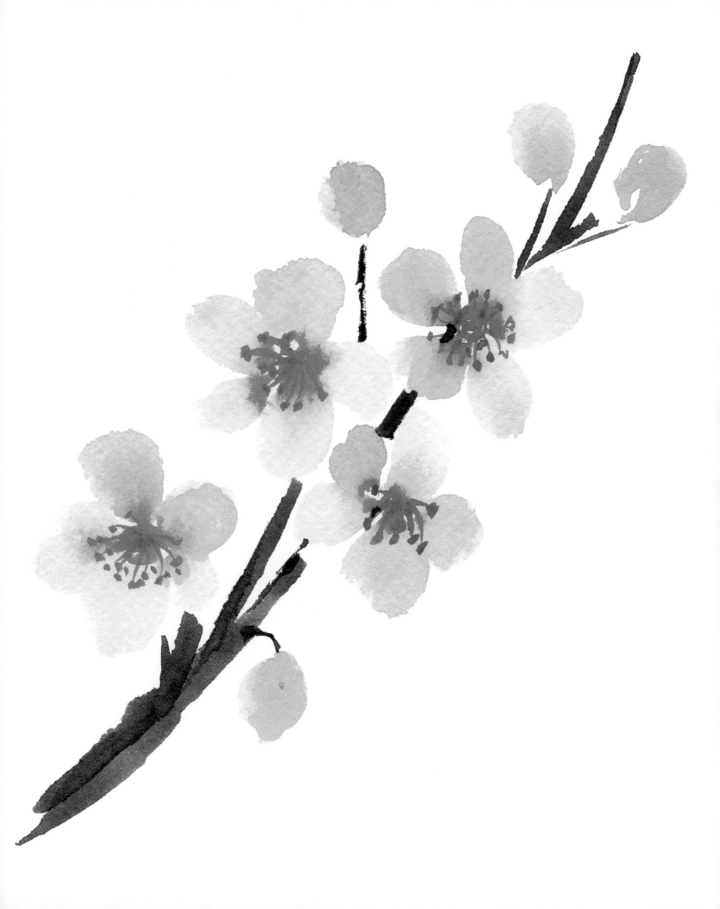

ANEMONE
LOOSE STYLE

Like a lot of flowers, anemones come in many different hues and combinations of hues. Deep purples, blues, reds, and whites are common colors in this species of flower and they can often be seen growing together.

This particular flower is one of my favorites to paint. The contrast of black stamen against white, pink, red, or purple petals is striking and commands attention. This flower, like the Cherry Blossom, can be broken down into a star shape. When painting loosely or in a more abstract way, you might not always have a guide or sketch laid out to follow as you paint, so for some, it can be intimidating to paint in this style, but with practice, you'll become comfortable with it. For now, if you feel you need help establishing the right proportions, begin by lightly drawing a five-pointed star and adding petals. But remember to stay loose, don't overthink it, and follow the basic shape.

POINT, PRESS, AND LOOP PETALS!

STEP ONE

To start, we're going to use a size 6 round brush to do all the work on these petals. The point of the brush is will make the base of each petal, while the belly will form the middle and top of the petal. Start by loading your brush up with a decently wet, but not too wet, light value of Ultramarine Violet and Opera Rose, making sure it's coating the tip and the belly of the brush. Next, with a slanted hold and pointing the tip of your brush toward where the center of the flower would be, paint in a thin line, apply pressure to your brush so that it fans out and makes a wide mark; then loop the brush around the top of the petal and come to a point again at the base. While the petal is still wet, load up your brush with a deeper value of Ultramarine Violet by dipping your brush into the paint—the paint will be thicker and darker. Then, using the tip of your brush, go to the base of the petal and punch in some of the darker value onto the wet, lighter value of purple. If the base of your petal is no longer wet, you will not get the diffusion you want, so make sure your first strokes are still wet!

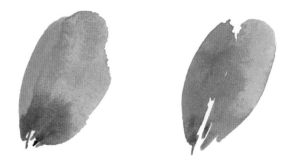

THE WHOLE FLOWER
STEP TWO

All right, are you ready for this? It's time to combine these simple strokes and wet-on-wet technique to create the shape of an entire flower. When it comes to watercolor painting, especially in a loose, modern style, it's important to not overwork or overthink. The ultimate goal with illustrating this anemone is that we follow the overall shape of a star. Sure, anemones can have more than five petals, but for now, we're going to keep it simple. With practice, this method becomes easier and you'll be able to naturally add more detail and petals.

Once you've made your first petal, add four more following the shape of a star, varying each slightly in color, shape, or size, and leaving a small, circular gap at the base of your circle of petals for stamen. Since I'm typically painting on a block, rotating the block of paper as I make my way around the star is very helpful. If needed, go back into the base of each petal with darker color to accentuate them a bit more. But remember, don't overdo this. With loose-style painting, we're capturing the essence and shape of a form, not trying to replicate it exactly.

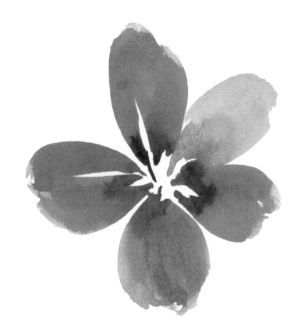

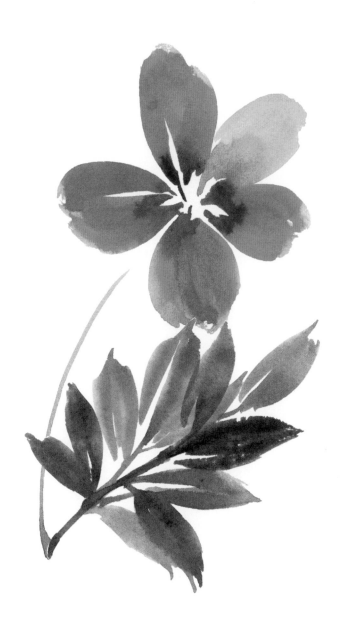

BULB, STAMEN, AND LEAVES

STEP THREE

While the petals of your flower are still drying, load your size 6 brush with a mixture of Permanent Sap Green and a touch of Lemon Yellow Deep for a yellow-green hue. Since we're working with purple petals, the complementary color for these petals is yellow. So, using yellow-green helps bring in a touch of contrast to the purple, making it appear more vibrant and eye-catching! From here, we're going to add the leaves by painting a stem using a vertical hold and the tip of the brush. Make sure that your stem pulls directly from the middle of the flower and curves out. In a flower, the base of each petal is connected to the stem and the stamen emerges from the center. If your stem doesn't point back to this spot, it will look off.

Once you've painted the stem for a section of leaves, use compound strokes (page 34) to add the leaves. The compound stroke is similar to the way we painted the petals, but instead of looping at the top, drag the brush using a light vertical hold to achieve a really thin, pointed tip. Do this a few more times to fill out the stem with leaves, varying your strokes in size, value, and hue to add movement and interest.

If looking at a photo or an actual anemone flower, you'll notice that the leaves are quite toothy and segmented. Don't try to replicate the image or reference exactly; rather, reinterpret the subject and allow your imagination to fill in the blanks. This style of painting will help you create something truly unique, but does take some patience. Add more leaves as you see fit, but keep it loose and don't overdo it. You can always add more detail later.

FINAL DETAILS

FINAL STEP

Next, use your size 6 brush again to load up with a very thick and opaque value of Mars Black. Before painting the center of the flower, make sure your petals are completely dry! If they're still damp, the black will blur and spread into the petals, creating a blob. Once you're sure the petals are dry, add the center of the flower directly in the middle of the petals. Now, you can be really precise with this step by painting an outline of a circle and then filling it in, or you can just make a couple of marks that allude to the shape of a circle. Try out both ways on a practice sheet of paper to see what you prefer, then add the stamen using a vertical hold and little to no pressure on the tip of your brush to give the center filament. For this step, you may find it easier to achieve thinner strokes with a size 2 brush, but either will be fine if you have control. Next, apply pressure to the tip of your brush to give these filaments anthers! Voilà!

Continue practicing this type of flower by repeating these steps for a multiple floral piece.

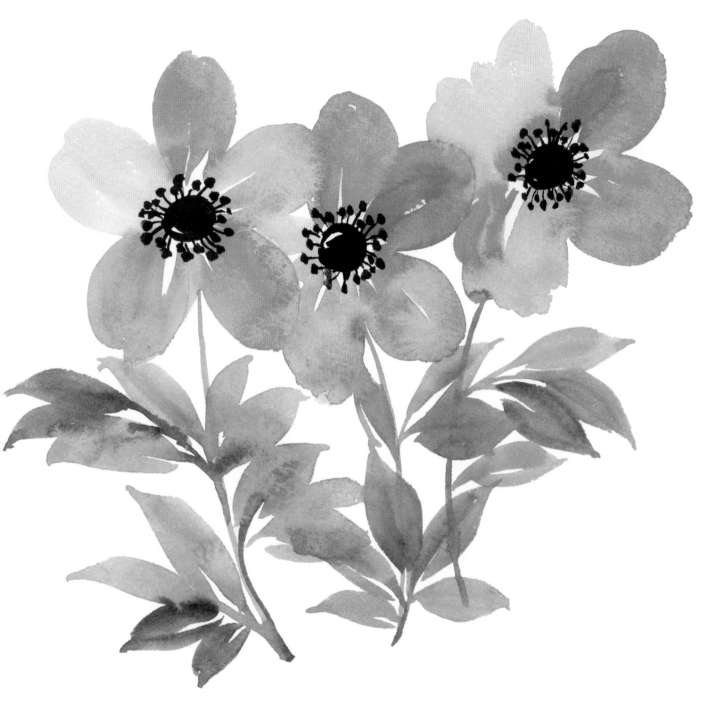

TIP If you're composing a full floral piece, fill up your paper with three or more anemones to start, adding slight variations in color, value, and overall shape with each. When composing a full floral piece, I typically like to paint the main floral heads first, then go in and fill in the white space with stems, leaves, and berries, adding the stamen of the flowers for the final step. Following this order helps when composing your piece because you can get the larger areas of your paper taken up first and then use other elements to create movement.

CLEMATIS
REALISTIC STYLE

Are you ready for your first realistic-style piece? I believe this style of painting, when approached with patience and a knowledge of how to use watercolor, is much easier than it looks. Contemplating painting a whole floral sketch, it can seem quite daunting, but take it one petal or one leaf at a time.

This first piece is going to be a clematis flower. A vine full of clematis in bloom is such a wonderful sight. Whenever the vine draped over the fence in the side yard of my childhood house was blooming, my mom would always make mention and have us come out and wonder at it. Their petals can be quite long and pointy and literally burst in both shape and color, dancing around swirly greenery.

As we saw with the Cherry Blossom and the Anemone, the star shape of this flower can be quite obvious when you look closely. There's a middle point on the flower that every single petal is connected to, like arms on a starfish. Clematis blooms don't always have just five petals, but a star doesn't always have five arms either. And, like most flowers, clematis comes in a variety of types and colors. I'm going to show you how to paint the *Clematis Jackmanii*, which is the same vine that grows in my parents' garden. It's main bloom colors are violet and red-violet with mid-green and yellow-green leaves and vines. Ready to paint?

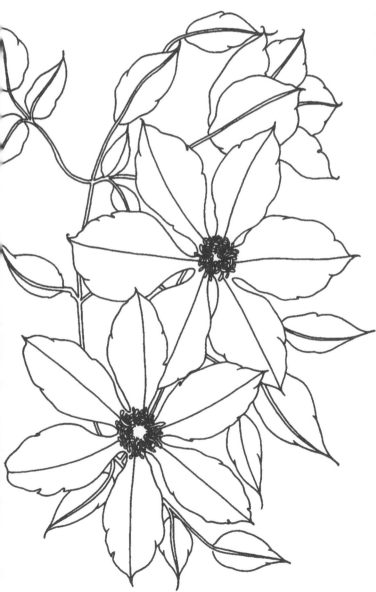

SKETCH
STEP ONE

For this piece, and for other realistic-style pieces, I've included a couple of images for you to use for color and structure reference.

To kick off the sketch, I've laid down an *S* curve in the shape I want the vine to be. Then we're going to sketch three clematis floral heads. Two of these will be flat and facing the viewer, and therefore star-shaped, while the third will be a newly opened flower, almost a bud, and viewed from the side, taking on a cup or bowl shape.

The first flower, at the top of the vine, is pointing up to the right, so when sketching this one, picture taking a star and turning it on its side and then pulling each arm up toward the center of the flower. The arms on the far side of the star will barely poke over the side nearest you. Add veins to each petal. Pull them out like *C* curves and make sure they're all pointing back to the center of the flower.

To make the other two flowers, instead of sketching an actual star first, we're going to do our best to create the shape with *C* curves. When you have the *C* curves for each petal down, start drawing the contour of the petal using *S* and *C* curves to create an oval or diamond-shape petal that comes to a point. Repeat these steps for each flower, changing up the angle of each to help create gesture and movement. Let some petals overlap, and add leaves that weave behind and overlap each other. The leaves are very similar in shape to the petals, so start with the main vein in the leaf and pull out the shape with *S* and *C* curves.

HIGHLIGHTS
STEP TWO

Throughout this book, especially within the realistic-style florals, you may notice a pattern: sketch, highlights, midtones, shadows. Watercolor is sometimes seen as difficult, especially realistic-style watercolors, because you must work light to dark, which is essentially the opposite of many other mediums. In watercolor, if you paint an area too dark, it's pretty much done for unless you can lift up some of the pigment with a paper towel or dry brush. Values and tonal ranges are all important, and applying them deliberately and with patience you can create a very detailed and realistic effect. Overall, the steps of a realistic-style painting are generally the same, with slight variations here and there.

Once you establish the hues you'd like to use for your subject, the next step is pulling out a range of values—a dark, a midtone, and a light—within each of those hues to create depth. These values will be applied in layers, mostly using wet-on-dry technique and sometimes using wet-on-wet when we want a soft blend of values.

To begin this piece, load up a size 6 brush with the lightest value of purple and wash over all of the petals. It's more interesting if your lightest value has some variation in it, so I've added some light red-violet along with a midtone violet and a touch of blue-violet. I've also added some slightly deeper values to this base layer to accentuate creases and veins in the petals; add these while the petals are still wet for diffused details that we will be darkening later.

When you have finished the petals, apply the same steps to the vines and leaves, using a light wash of yellow-green and a light brown for the vine/stem.

MIDTONES
STEP THREE

Once the highlight layer has dried, it's time to pull forward some of the vein details and folds in the petals and establish where the shadows will be. It's important to show the curve in each petal, so paint in midtones and blend or soften the edges using wet-on-wet technique to avoid hard edges. The smaller midtones on the outer edges that show folds on the petal are a wonderful texture to add. Make sure they're soft and a similar hue to the petal. Use a size 2 brush to paint in these smaller details. As in the highlight layer, make sure you're incorporating multiple hues and that they all blend with one another nicely.

Apply these same steps to the leaves and vines, bringing out veins in the leaves by painting midtones around them.

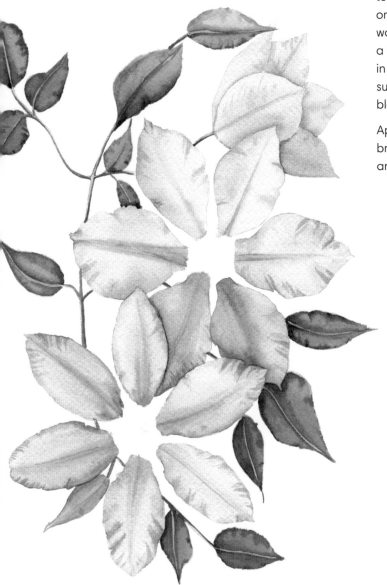

SHADOWS AND DETAILS
STEP FOUR

Now it's time to make the veins and details in this flower really shine. Using your size 2 brush, work your way around each flower and element of this piece with your darkest values, creating really clean edges on your shadows, accentuating veins and curves. Once these shadows have been added to the flowers and then to the leaves and stems, load up your size 2 brush with a yellow-green mixture and add a ball shape in the center of each flower. Once this dries, whip up a deep mixture of Burnt Umber, Ultramarine Violet, and a touch of Mars Black to paint the stamen. These strokes should create a spikey ball formation in the middle of each flower and should all be attached or pointing back to the yellow-green touches in the center of the flower. Be sure to overlap some and curl some over, as this is how they would appear in nature.

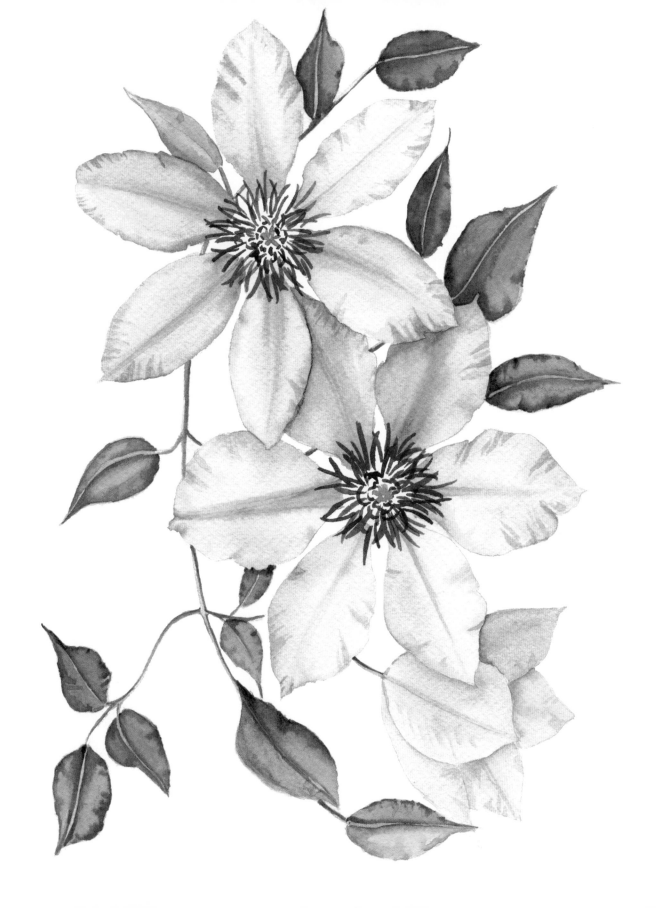

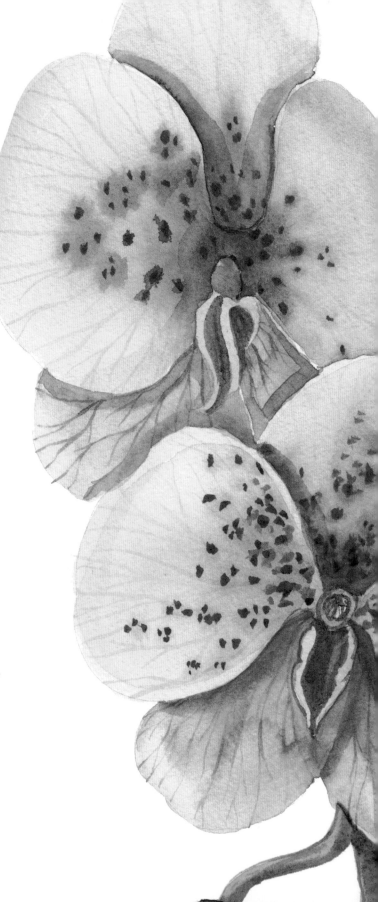

ORCHID
REALISTIC STYLE

Orchids come in all shapes, colors, and sizes. There are more than one thousand species of orchids, and each one is incredibly unique and beautiful. I wasn't always a fan of orchids—I thought they were odd looking—but have you ever looked closely at this flower? So many twists and turns, and the gradation of color is stunning and like nothing else.

For this particular piece, I've chosen to paint the Vanda Sanderiana, which is known as the Queen of Philippine Flower. The colors in this flower aren't the whites and purples, yellows and pinks you'd normally see in orchids. This variety of orchid is dressed in dusty and pale pinks, taupes, and deep brown-purple freckles. This orchid is a work of art, and I can't wait for you to paint it!

SKETCH
STEP ONE

For our final star-shaped floral we're going to switch things up a bit. I bet by now you're used to the sketch, highlights, midtones, shadows rhythm, but this time around, I'm going to show you a slightly different style of painting. We're pretty much going to keep that same order, but our first painting layer is actually going to be the darker, veiny details in the petals; once that's dry, we'll wash our highlights and midtones over the dark veins. But first, let's sketch out our piece.

For this painting, I have made the flowers a bit larger, taking up the top two-thirds of my paper. This is an interesting composition: since the top half of some flowers is cut off, the viewer has to imagine the rest of the flower. It leads your eyes from the top corner, down through the buds and stems, and curves to the bottom, opposing corner. For your sketch, follow along with the sketch guides I have included, but don't be afraid to let inspiration take over.

Start by sketching three large orchid heads in the top right-hand corner. Follow the overall star shape as a guide for this flower and draw the petals and sepals as ovals, making sure the sepals sit behind the petals. Each petal and sepal should come back to the center point of the flower. Once you're done sketching ovals, you can refine the contour of the flower and erase the ovals.

VEINS
STEP TWO

All right! It's time to get this pretty thing started. With a size 2 brush and a deep dusty-pink color, almost mauve, paint in the darker-colored veins on the bottom two sepals of one of the flowers. You could mix up this mauve color with some Burnt Umber, Scarlet Lake, Opera Rose, and a touch of Yellow Ochre! If you look at a Vanda Sanderiana orchid, the top half is much lighter and mostly monochromatic, while the bottom half has a yellow and taupe petal color with darker veins. Start with these bottom veins, then lighten up your mixture a lot and paint the lighter veins on the top half. Repeat these steps on the remaining flowers, only applying veins to the petals and sepals, and avoid the lips and stems.

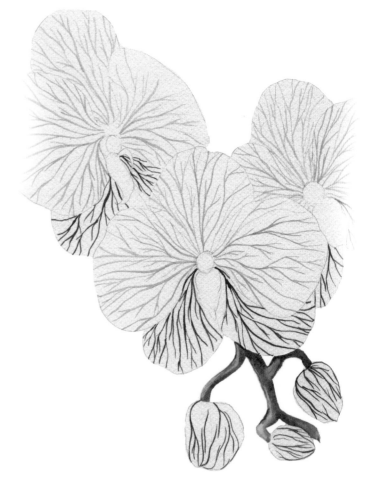

MIDTONES
STEP THREE

Yep! That's right. We skipped highlights. Instead of painting a layer of highlights, we're going to paint midtones and, while this layer is still wet, use a paper towel to lift color off to lighten areas that should be highlighted.

Mix a midtone value of a taupe-pink for the bottom half of the flower and a soft pink for the top half, avoiding the lip area of the flowers. Using wet-on-wet, load up a size 6 brush and fill in each petal, punching in darker values where needed as you go. For example, while painting the bottom-right petal on the lowest flower, start with a slightly lighter value of taupe-pink, then punch in a darker value of this color along the edge where this sepal is overlapped by the petal above. Wet-on-wet technique will show a soft transition of darker to lighter values. When two petals touch, don't paint the neighboring petal until the first one is dry; move on to a petal that does not touch the wet petal and come back to that one later. If you paint a petal when the one next to it is still wet, the colors will all run together.

Repeat these steps until all the petals have their midtones.

Next, use a light yellow-green to paint the stem, adding a darker green wet-on-wet in areas where the stem is shadowed.

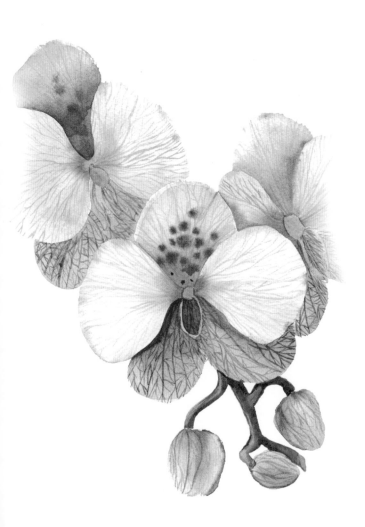

FINAL DETAILS
STEP FOUR

Once the previous layer is dry, it's time to add the lip of this flower. Use your size 2 brush and start with a yellow-green at the top of the lip, gradually mixing it with taupe, then taupe with dusty rose as you work your way down the lip. The largest portion on the bottom of the lip should be mostly dusty rose, but make sure to vary this slightly on each flower so that it doesn't look too uniform. From here, add any final details to the stems, like bumps, deeper shadows, etc., take a step back, and see what the rest of this piece calls for. Add in freckles to the petals using the tip of your size 2 brush and a dark mauve mix.

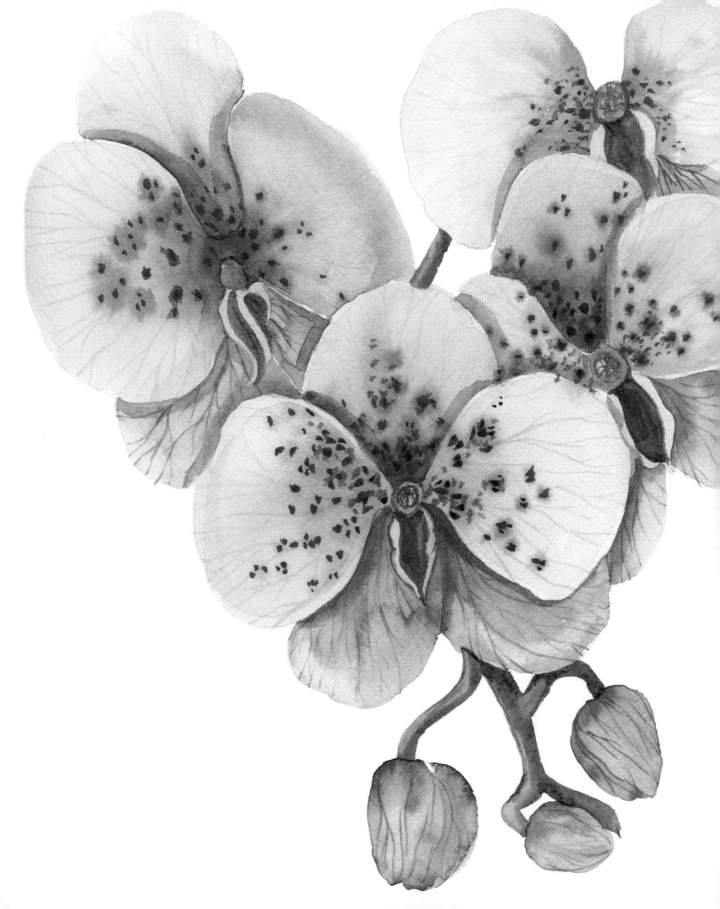

CIRCLE SHAPE
CHAPTER TWO

In this chapter, we're going to build on what we did in chapter one. A lot of the structure and technical stuff will be the same, but we will be practicing and building muscle memory for a different shape.

Circle-shaped flowers are some of my favorite types of flowers to sketch and paint. Some of these subjects may be intimidating—there's lots of petals and details—but with some tricks, like starting our sketch with a circle and then adding detail, I think we'll do pretty well! Before we jump into the first circle-shaped flower, let's warm up with a few sketching exercises to get you familiar with the configuration of these flowers.

Using your sketching pencil, lightly sketch an oval on some practice paper. Ovals and circles are hard to get right on the first try, so swirl around in a circular motion three or four times to get your shape right. From here, come back around to the base of that first oval, then extend outward to the left or right for another oval, making sure the base of this oval connects with the base of the first. Do this a few more times, until you have four or five ovals. These ovals are the guides for your petals! Now follow the oval outlines but add details, like texture and tears, dips and points to suggest petals.

Continue to practice this warm-up exercise, as this will be our starting point for the following four flowers, as we start loose and work our way to more detailed and layered flowers, like the Eden Rose.

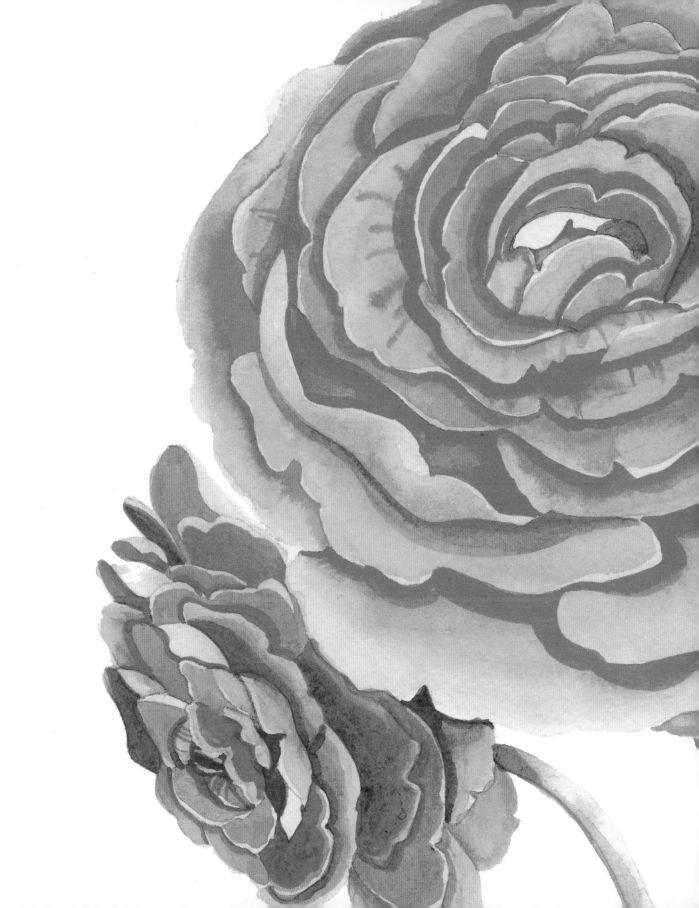

SUNFLOWER
LOOSE STYLE

Our first circle-shaped flower is going to be the brilliant and bright sunflower. I never used to think much of sunflowers, because of how common they are where I'm from, but after visiting the countryside of France and stumbling upon a sunflower field, they have become one of my favorites. They can be so simple to paint, but hold a sunset of colors in their delicate petals. The circumference of a sunflower is a circle, with all the petals being roughly the same length.

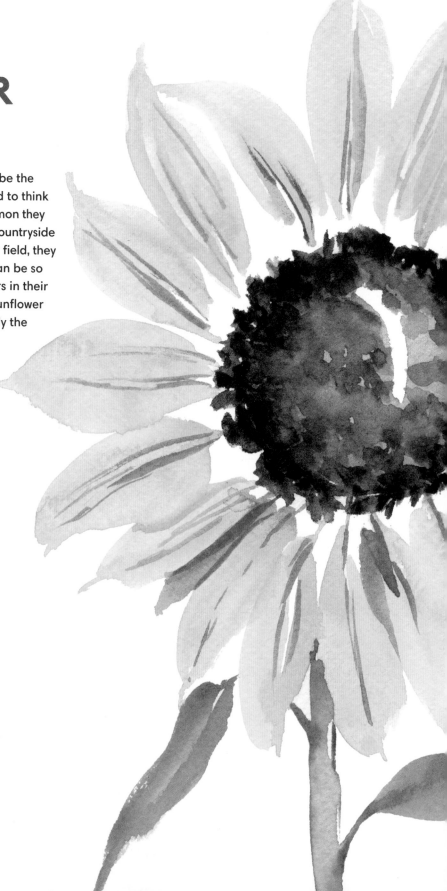

THE DISK
STEP ONE

For this flower, we are going to use only a size 16 brush! A one-brush painting! Because of the large size of the parts of the flower—the center, the petals, and the stem—we won't need to come in with smaller details using a smaller brush.

To start, load your brush up with a highlight value of Cobalt Blue with a touch of Mars Black and paint a wet circle, one or two inches in diameter, in the middle of your paper. You can fill in the circle completely or leave a few gaps for white paper to show through as a bright highlight, but fill in most of it, and use enough water to be sure the disk will stay wet while we add the stamen dots around it. Now, load up with more Cobalt Blue and punch in this color around the disk randomly to create light shadow and sheen, and then add Burnt Umber around the rim of the disk and a few dots of Mars Black around the outside as stamen.

PETALS, STEMS, AND LEAVES
STEP TWO

Without waiting for the center to dry, wash your brush off completely and load up with Lemon Yellow Deep. To paint a sunflower petal, use the tip of your brush to drag out a thinner line that just barely touches the disk of the flower and then curves away. Add pressure to your brush, press down, and drag your brush in a C curve, then release pressure for a thin tip. This is similar to how you'd paint a basic leaf, but longer. Repeat that same step for the other side of your petal, making sure the base and tip meet up. Change up the size, values, and hues of the petals as you work your way around the disk. Visualize and follow the overall shape of a circle, and add touches of oranges and reds to the outer edges of some yellow petals to lend depth and variety.

Next, load your size 16 brush up with a yellow-green mixture. Using the tip of your brush, paint in a stem that points back to the center of the flower. Then add a few leaves around the stem using the same method you just used to paint the petals. Create depth by darkening the leaves with Sap Green in some places.

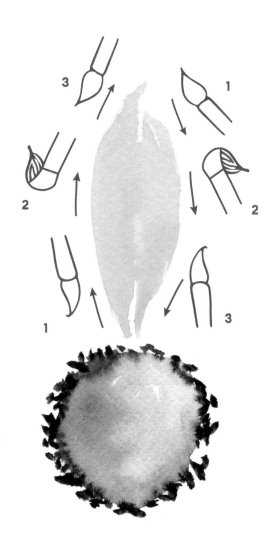

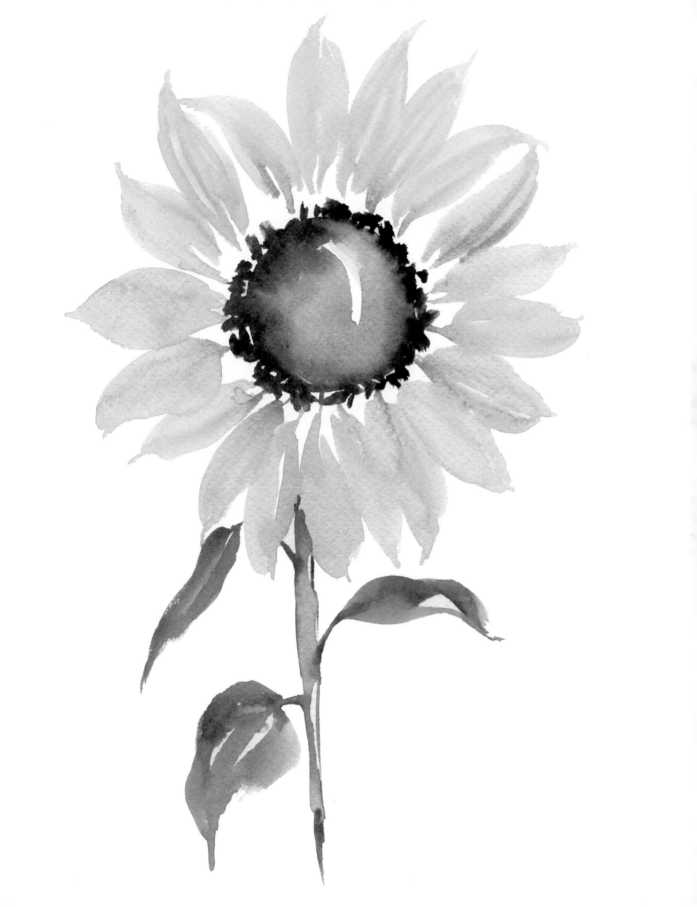

DETAILS
STEP THREE

For our final step, we're going to add some detail to the disk and the petals. Go back over each part of the disk area with dots of a darker hue, leaving some of the base wash showing underneath, and add some more darks to the stamens. If you're adding detail to a part of the disk that is Cobalt Blue and Mars Black, add detail using a darker value of the same colors, allowing some of the original wash to show through. Or if it's brown, mix up a darker value of Burnt Umber and add that. Next, load up with a mixture of Cadmium Orange and Burnt Umber, and use the tip of your brush to go over parts of the petals and pull out crease details in each petal. Keep these details very minimal so that the washy aspect of this painting shines through.

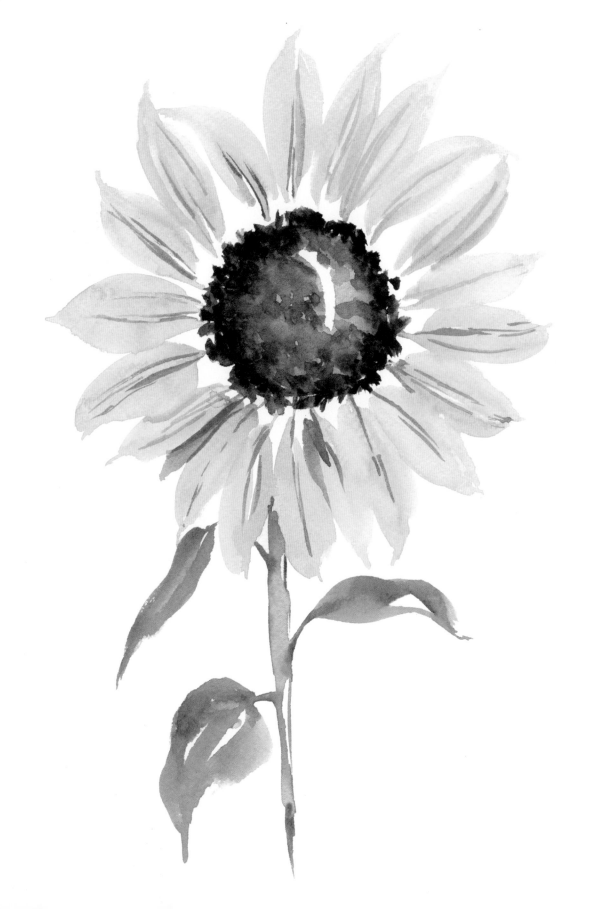

DAHLIA SCURA
LOOSE STYLE

The Dahlia Scura is such a stunning flower. Most people think of fluffy, layered petals when they think about a dahlia, but today we're going to be painting a single bloom, which just has one layer, or row, of petals. This flower, like the Sunflower, is a circle shape, with a ball in the center for the stamen. We will mainly use wet-on-wet blending for a two-toned effect. We're going to be painting a stunning dusty orange and red dahlia with bold gradations.

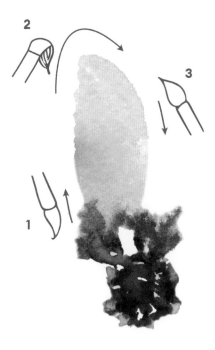

STAMEN AND PETALS
STEP ONE

For our first loose-style dahlia we will start with the stamen. The color of this particular stamen is the same as the deepest hues in the petals. If you search online for an image of "Single Dahlia Scura," you'll see a bunch of images pop up of the flower we're painting.

Fill up a size 6 brush with a deep red hue using Scarlet Lake and Burnt Umber and paint in dots that make a circle shape.

Wash your brush off completely and load it up with an Opera Rose and Yellow Ocher mixture and paint in petals. Make sure your petals are connected to the stamen just a touch, so the color in the stamen bleeds into the petals. Wet-on-wet will produce a wonderful looseness and unique color gradation between stamen and petals.

These petals are very similar to sunflower petals, but they curve at the top and should be painted in one stroke. They are pretty much just ovals. As you're working your way from petal to petal around the stamen, make sure to vary the color, adding some darker color here and there or maybe a touch of just yellow here and there.

BUDS
STEP TWO

Before adding stems and leaves, we'll paint the buds, which will help direct the flow and composition of the piece. I generally prefer designing my floral pieces in an S shape across the paper, and once I've placed my flowers and buds, I can see where I need to add stems and leaves. In my floral watercolor classes, students often ask me where they should add stems and leaves when they only have one flower on their paper. Get your main flowers and buds down first, then decide where to add the leaves to enhance your design.

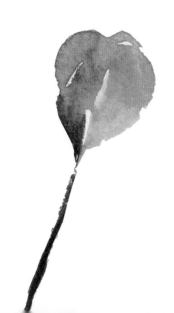

STEMS AND LEAVES
STEP THREE

Now that you have your main flowers down, let's fill in some white space with stems and leaves. Using a mixture of Burnt Umber and Ultramarine Violet and holding your brush vertical, paint in a stem that leads to each flower or bud and that curves just a bit. Next, add a touch of Sap Green to this mixture and paint leaves. To make the composition more interesting, use some overlapping by adding leaves behind the flowers.

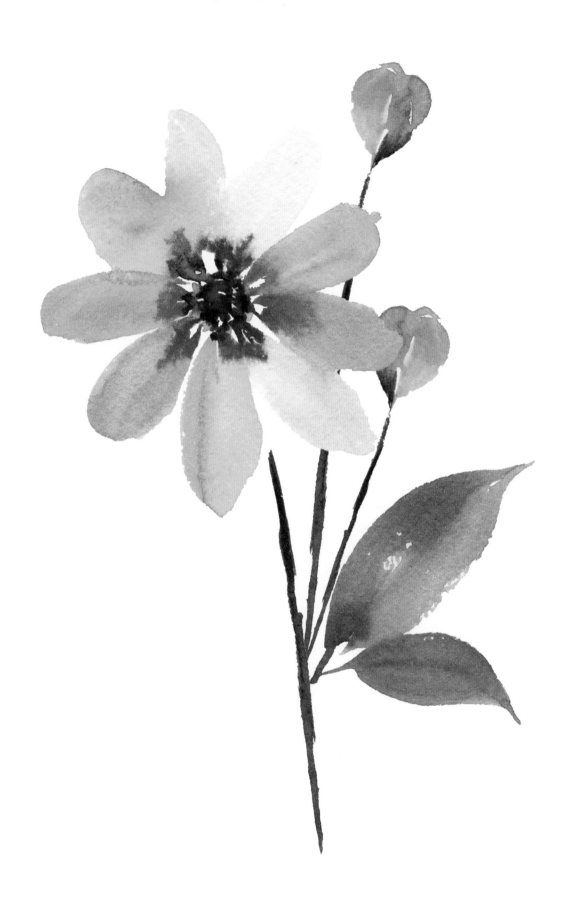

RANUNCULUS
REALISTIC STYLE

One of my favorite flowers to paint happens to be a ranunculus. There are so many varieties of this flower, but one of the most popular, the Persian Buttercup, is what you commonly see at a flower shop or in a bridal bouquet. This circle-shaped flower has a lot of petals, which, if you look closely, seem to form a spiral around the center.

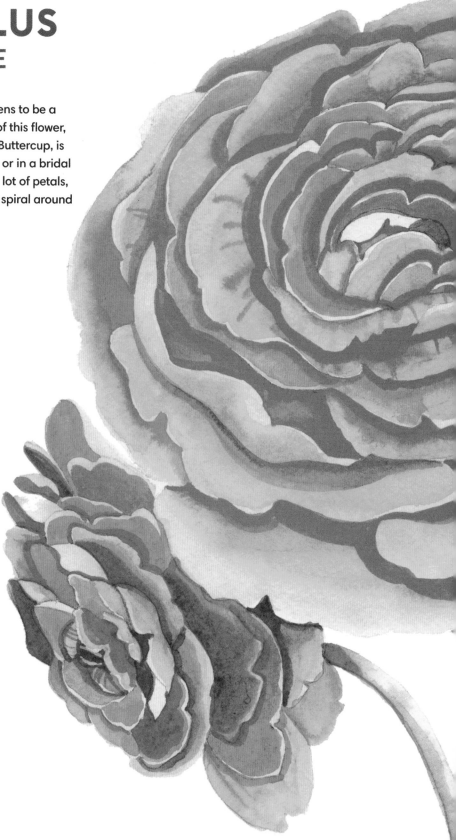

SKETCH
STEP ONE

Now that you've worked through two circular floral shapes, it's time to take that practice to a new level with a more precise style of painting. Let's begin by lightly sketching a circle, then adding a smaller circle in the middle. Draw the stem coming from the inner circle. Now, starting at the inner circle, start adding concentric rings of petals. Vary the length and contour of the petals so that they don't all look the same, until you get to the final layer of petals, at the edge of your outside circle. Make sure every petal points back to the inner circle: This is where the stem connects to the flower, so every petal should be growing out of this spot!

These circle guides help you achieve the correct dimensions and shape and help simplify a complicated subject, but if you feel comfortable sketching this flower freehand, there's no need to start with the circles.

Add another flower and a bud to your sketch, and give each C-curve stems.

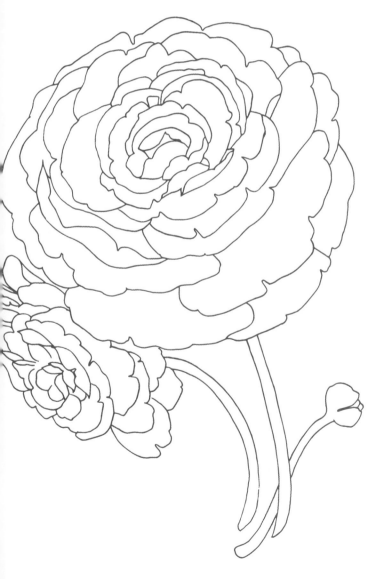

HIGHLIGHTS
STEP TWO

With a size 6 brush loaded up with a light value of Opera Rose and a touch of Ultramarine Violet, wash over your entire sketch. Added a touch of Lemon Yellow Deep and light Sap Green to show the newness of the petals nearest to the center and to add some variety. Make sure to stay in the lines and change the hue slightly in the next flower so that they don't look exactly the same.

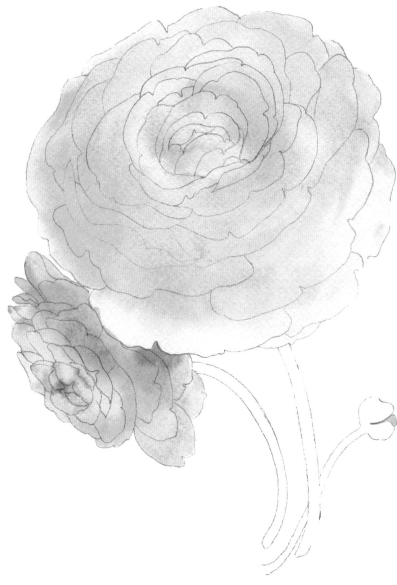

MIDTONES
STEP THREE

Once your highlight layer is dry, develop the creases and folds of the flower by adding darker values of your base hue. Use wet-on-wet technique on large petals that are facing the light source, showing a gradation from midtone to highlight; start with your midtone value near the shadow area or base of the petal and diffuse it by adding water to your brush and pulling the color as you make your way across the petal until it matches the highlight value. Use your size 6 brush for most of these midtones, then a size 2 for all the tiny areas.

Wet-on-wet is also a great way to show subtle petal details, like veins and folds. While the base of a petal is wet, paint in a thin C curve that follows the curve of the petal and watch it bleed.

Apply these same techniques to the stems and leaves. But be sure the flowers are completely dry first so that the pink and greens don't bleed.

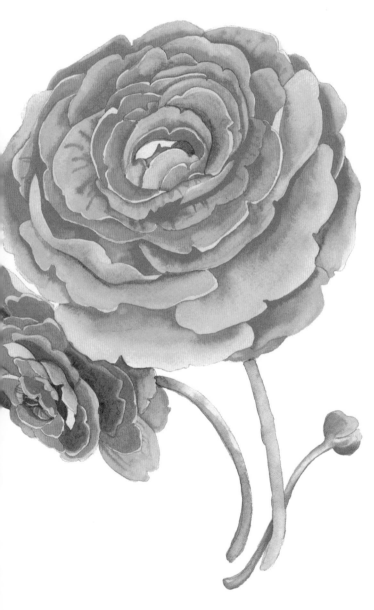

SHADOWS AND DETAILS
STEP FOUR

For the final shadows and details, take your size 2 brush and add shadows using your darkest values. Accentuate areas that are tight and blocked from the light source, veins in petals and leaves, and maybe even add speckles of spots on petals.

It's so exciting to see a flower like this, with so many petals, come to life! All it takes is some patience to make a wonderful, realistic painting!

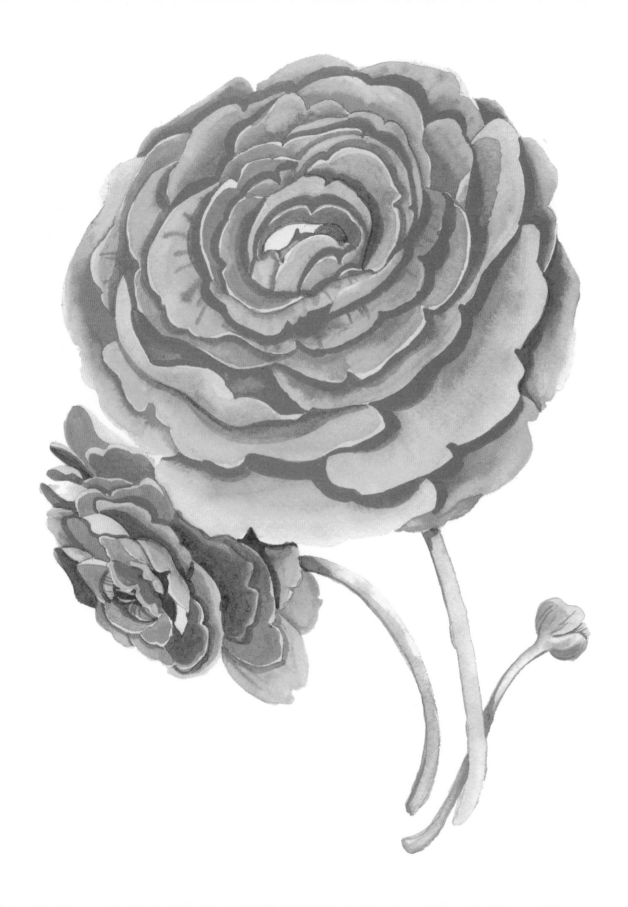

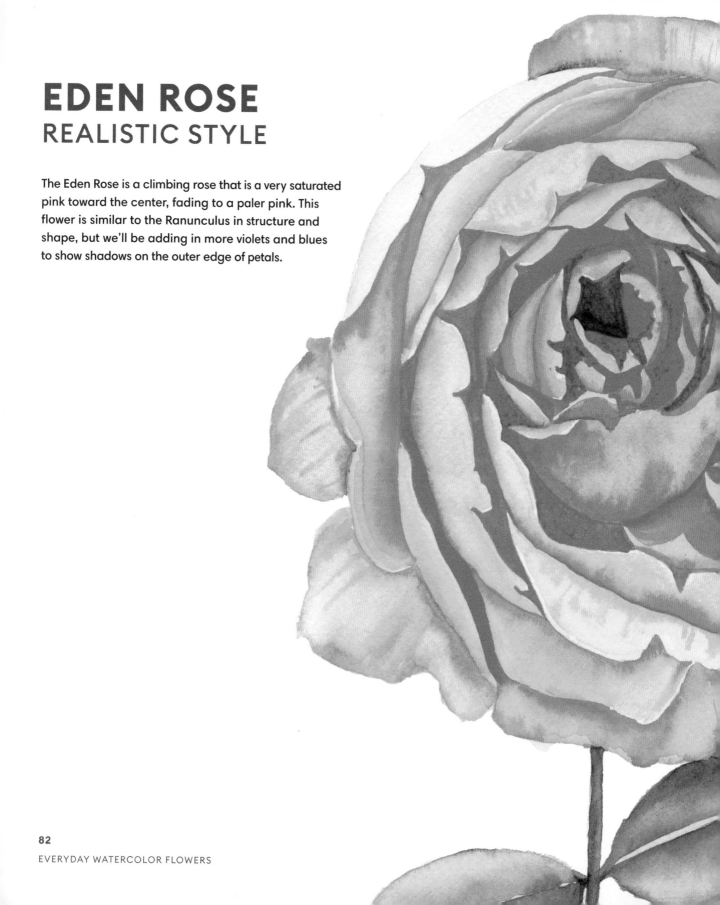

EDEN ROSE
REALISTIC STYLE

The Eden Rose is a climbing rose that is a very saturated pink toward the center, fading to a paler pink. This flower is similar to the Ranunculus in structure and shape, but we'll be adding in more violets and blues to show shadows on the outer edge of petals.

SKETCH
STEP ONE

For this sketch, we're going to start off with the same guides and petal shapes as we did for the Ranunculus. But, when you get to the outer edge of this flower, start making the petal shapes more triangular. Finally, add a main stem with C-curve leaves.

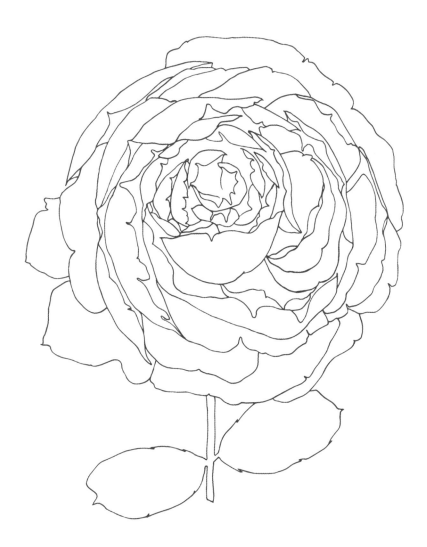

HIGHLIGHTS
STEP TWO

The Eden Rose has a very vibrant center, then, as it expands, the petals become much lighter and sometimes white, so it is important that your highlight wash be gradated. Start in the center with your lightest value of Opera Rose and, as you make your way outward, gradually keep lightening the color on your brush with water, until you get to the outer rim of the flower. Using wet-on-wet, punch in pinks and yellows that will gradate into the lighter highlight. The top edge of some of the larger petals will have a darker pink hue on the rim, so add this to some of the outer petals. Make sure your flower is completely dry before adding the highlight layer to your stem and leaves so that the pink and green don't mix together.

For the leaves, use a light yellow-green as your base and punch in lighter browns and slightly darker greens around the edges of the leaves.

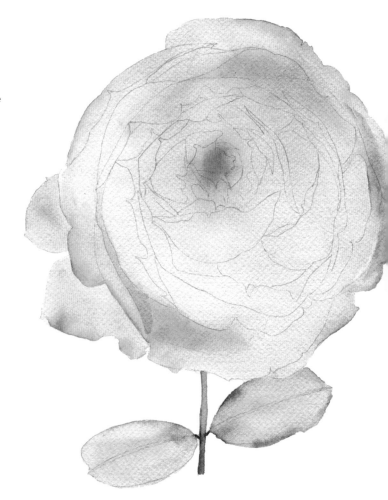

MIDTONES
STEP THREE

Start adding the midtone in with the center of the flower. Remember, don't go too dark with this layer because it may be difficult or even impossible to go back. Use a size 2 brush and your midtone mix of pinks and creamy pinks (with a little Yellow Ocher) to paint in your midtones.

When you get to the outer petals, use cool grays, with a base of blue, to help accentuate the light value more. With a very light mix of cool gray on your brush, paint in the cast shadows on petals and around vein details. Use wet-on-wet technique to softly punch in pinks and yellows and watch the petal come forward. Use deeper pinks in petals that are being overlapped by folds or other petals and for the innermost parts of the flower. As you paint the midtones on the leaves, have a small, dry brush close by to use to lift small lines of paint to make veins. The paint can't be too wet, though, or the lines will fill back in. Lifting is a good way to show delicate, subtle veins in leaves.

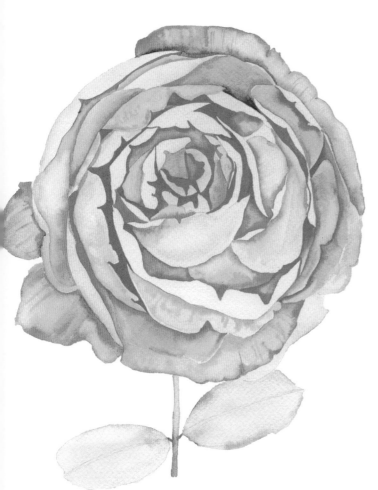

SHADOWS AND DETAILS
STEP FOUR

Once the midtone layer has dried, add the veins and details around your highlights and deepen any midtones that need it. Use your darkest green mix and accentuate the vein detail by painting in shadows around the veins. Then, with a slightly darker cool gray, add thin speckles and veins to the lighter, slightly pink petals. Be careful to not overdo this part in order to keep the white areas light.

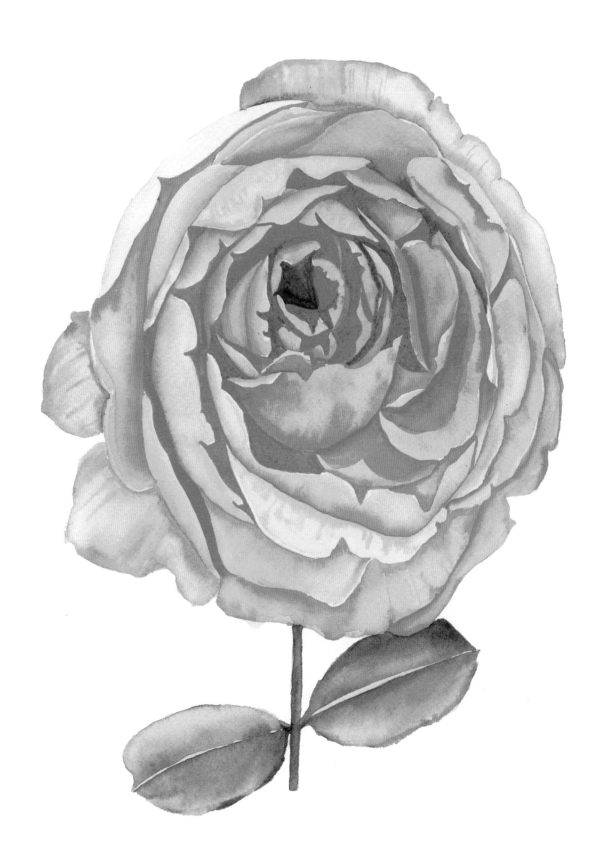

BELL SHAPE
CHAPTER THREE

The bell-shaped flower can be tricky to capture—it is curvy, both convex and concave. Picture a ball, or sphere, at the base of each bell. To draw the flower, pull up an *S* curve that tightly hugs the ball, curves inward, and then curves back out again to wrap around a larger oval that forms the mouth of the flower.

Sketching bell-shaped flowers or painting them in a loose style isn't going to be that difficult; the trickier lesson to grasp will be the shadow layers in the realistic paintings, which need to follow this *S* curve in order to convincingly portray a bell-shaped flower.

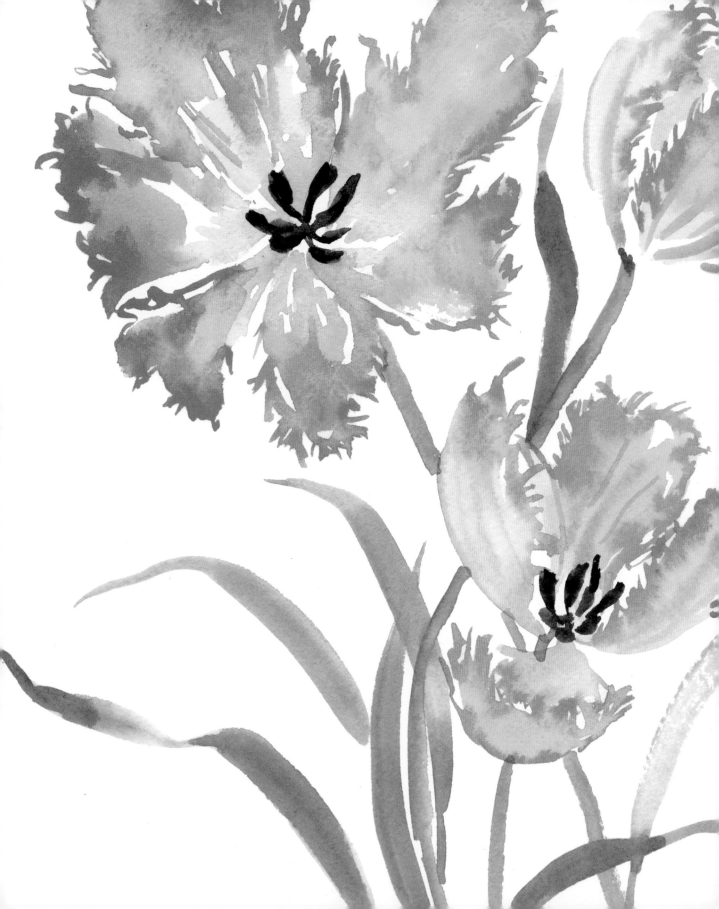

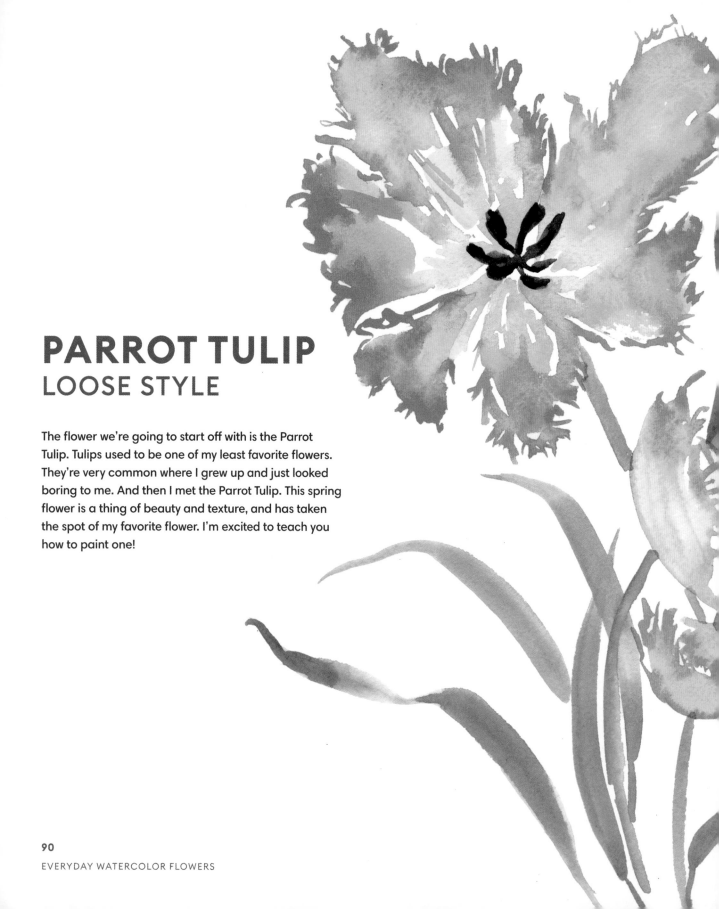

PARROT TULIP
LOOSE STYLE

The flower we're going to start off with is the Parrot Tulip. Tulips used to be one of my least favorite flowers. They're very common where I grew up and just looked boring to me. And then I met the Parrot Tulip. This spring flower is a thing of beauty and texture, and has taken the spot of my favorite flower. I'm excited to teach you how to paint one!

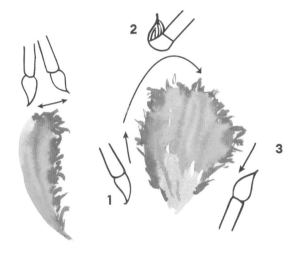

POINT, PRESS, LOOP

STEP ONE

Load a size 6 brush with a light mixture of Opera Rose and Scarlet Lake to paint one of your side-facing petals first. Using a slanted hold, put the tip of your brush at the base of where your flower will be, then press down so that the brush fans out, drag it up, around the top, then back down to form a petal. Point, press, loop! While this petal is still wet, load up with a darker value of pink, or whatever your base hue is, and give the petal some hair-like texture along the outer edges. Parrot Tulips look like they have bed hair, so make it crazy, but remember to not overdo anything. Punch in some Lemon Yellow Deep, or a yellow-green hue to the base of the petal for a gradation of color.

ALL ABOUT THE SHAPE

STEP TWO

Now, we'll repeat step one to paint the remaining petals.

Always keep in mind that the basic shape of this flower is a bell. Imagine there's a ball at the base of the flower and the petals are cupped around it. As the flower opens, picture the petals peeling back and how they would fall. All of your petals should be pointing back to the same base and curving around it. So, for your closed tulip, paint the sides first, then the front petal, and then the back petal, which is only seen poking over the front petal.

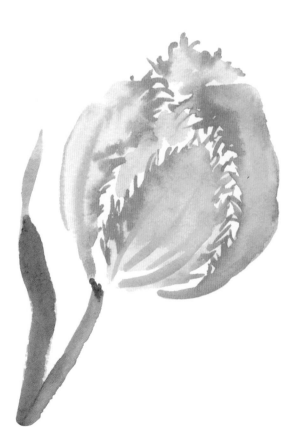

STAMEN, STEMS, AND LEAVES
STEP THREE

Once all the petals are dry, mix up a dark value of Burnt Umber and Mars Black for the stamen and paint them using the tip of your size 6 brush for the filament; then press at the end to give it width. Paint your stems, using an angled hold, with a hue of yellow-green, making sure to curve and show movement. The leaves for these flowers are similar to the leaves we painted in the section on compound strokes (page 34). Make some bent and others straight, some longer or different hues than others to add dimension to the piece.

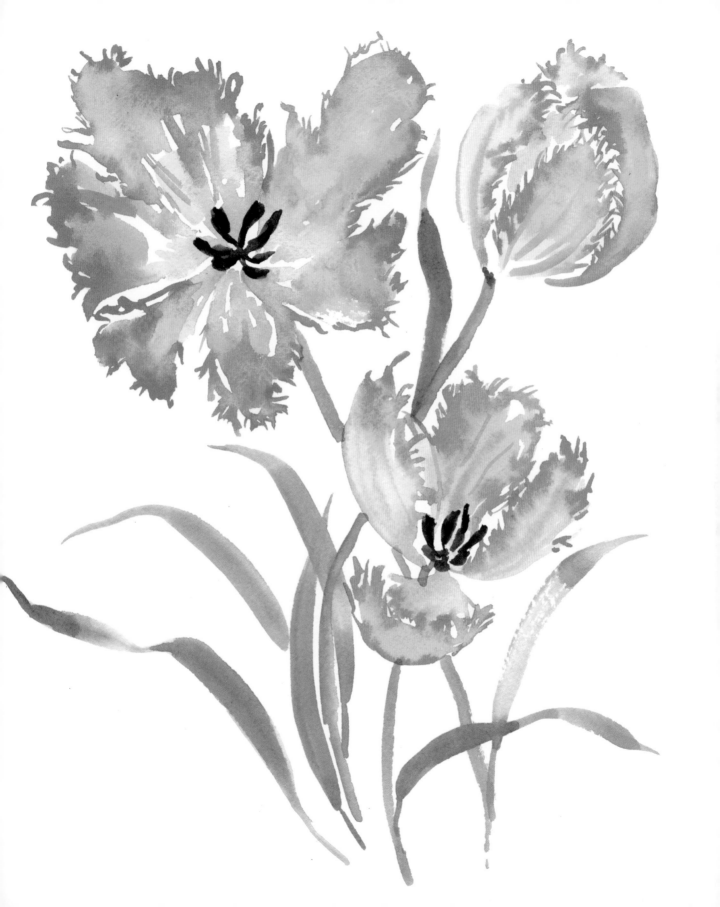

ENGLISH BLUEBELL
LOOSE STYLE

For these delicate flowers, we're going to describe
the bell shape with just one or two strokes per flower.
Bluebells are quite small and dainty, and I think the
color and the curve of the stem are what's important
to capture here.

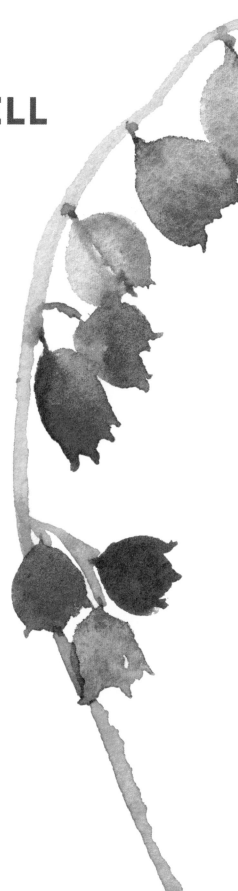

LOOP AND CURL
STEP ONE

Fully load a size 6 brush with Cobalt Blue. Using a slanted hold, guide the belly of your brush through a loop, keeping the belly of the brush on your paper through the whole stroke. Once you've painted your loop, use the tip of your brush to flick out curls along the bottom edge. Add deeper color or a slightly more purple hue, wet-on-wet, when you do this to get some nice variation in color.

FLOATING FLOWERS
STEP TWO

Continue painting bluebells, using a slightly different hue or value of Cobalt Blue and Ultramarine Violet. It's important to think about the shape of your stem while doing this. Typically, English Bluebells grow on a thin long stem that arcs at the top with the flowers draping down like little bells. Change up the angle of each flower and the space between them.

STEMS
STEP THREE

Finally, load your size 6 or a size 2 brush, depending on how small you painted, and, with a vertical hold, use the tip of your brush to paint your main stem. Start at the bottom and paint straight up, then curve at the top, kind of like a staff. Let some flowers be in front of the main stem: to do this, simply paint up to the flower, stop, and start again on the other side of the flower. Next, attach your flowers to your main stem with little C curves.

Continue practicing by painting multiple stems of these flowers. Bluebells are one of my favorite flowers to paint as a filler or accent in larger floral pieces with multiple flowers.

FOXGLOVE
REALISTIC STYLE

For our first realistic-style bell-shaped flower, we're going to paint the foxglove in a deep, mauve-purple hue. The curves and details on this flower are crucial, so take your time with that layer and really accentuate its S shape!

This is such a fun flower to paint! I love the detail and character in its freckles. It also allows you to practice wet-on-wet technique as well as lifting and dry brush technique.

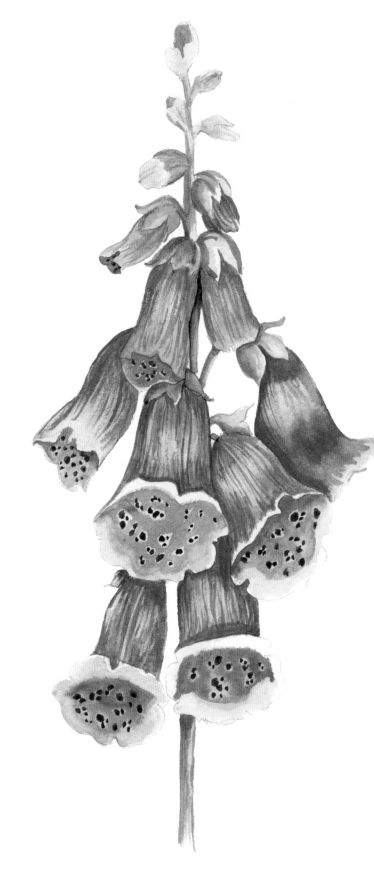

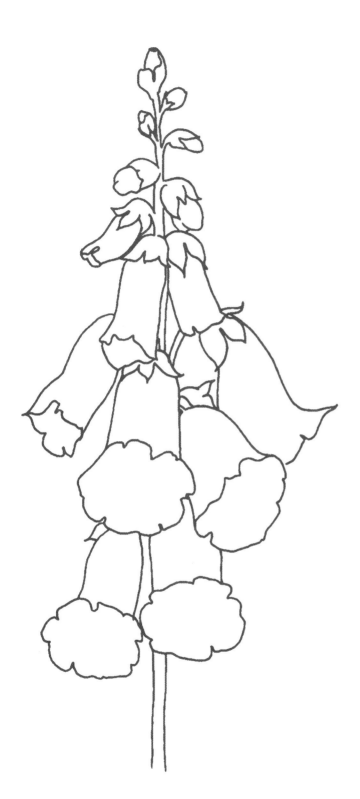

SKETCH

STEP ONE

If you're struggling with the sketch, start with a light pencil line 4 to 5 inches tall for the stem and, one by one, add in actual bells staggering up and around this line. As you work your way up the stem, sketch smaller bell shapes and eventually just use ovals at the top for buds. Then, go in and add the contour of the petals and sepals for each flower. Thicken the stem at the bottom and erase the parts of the stem hidden behind flowers.

HIGHLIGHTS AND LIFTING
STEP TWO

The perspective of each bell-shaped flower is important to take note of to create depth. When seen from the side, the bottom of the bell where it narrows before flaring out will be in shadow, then as it curves up around the edge, in highlight. Inside the opening of the bell will be the deepest shadows. The highlight on top of the bell is important to show its curve. When we paint the highlight layer for each foxglove, we're going to use a dry brush or paper towel to lift color from this spot as we go along to keep it very light.

Paint the highlight layer on nonconsecutive flowers to avoid bleeding, using a mix of Opera Rose, Ultramarine Violet, and a touch of Burnt Umber. Then, once dry, add in the highlight layer for the stem and leaflets. Drop in color as you go for softly blended midtones, but keep everything very light at this stage and make sure to lift color from each bell to create highlights.

For the inside of each bell or flower, apply water to the entire inside of the flower, then punch color, leaving a thin gap at the lip of the bell. While your paint is still wet, use a dry brush to lift spots of color. In our final steps, we will be painting speckles and spots into these lifted areas.

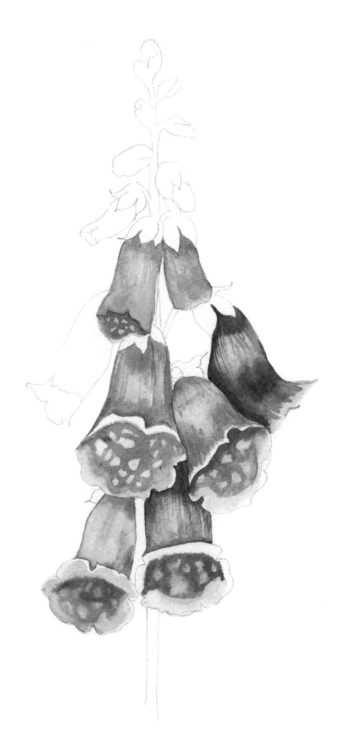

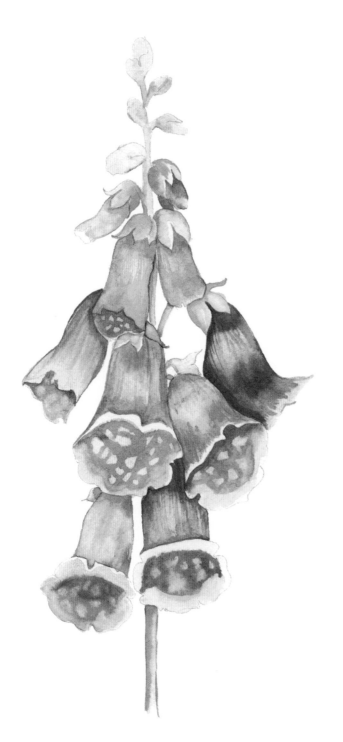

BUILD IT UP
STEP THREE

Once a flower is dry, use your size 2 brush and feather in darker vein hues toward the highlight. Make sure to follow the curve of the flower. Don't press too hard, and keep the lines close together to show consistent shading. When flowers overlap, make sure the veins and shadow details are darker on the flower in back. Add shadow and texture details to the stems and sepals—smaller green leaves holding the flowers with a darker green.

FRECKLES!

STEP FOUR

For the final step, use your size 2 and a deep hue of Ultramarine Violet, Opera Rose, and Mars Black to paint in the freckles or spots inside the mouth of each flower.

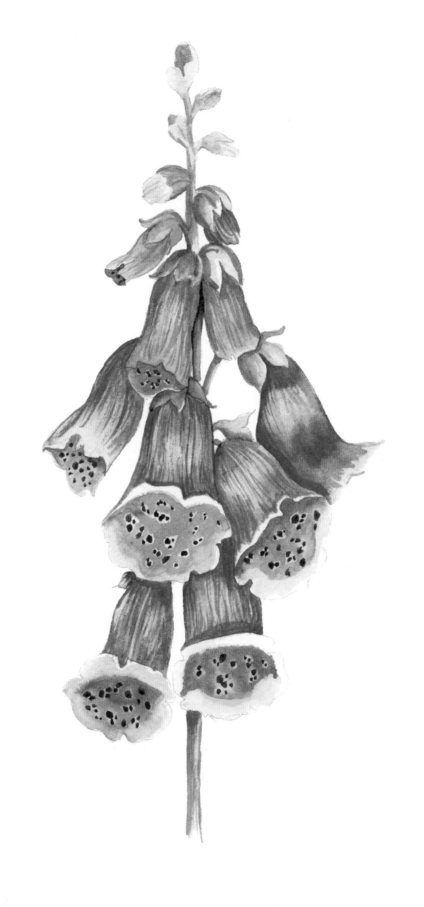

PENSTEMON
REALISTIC STYLE

I love this flower's nickname: beardtongue. How fun
is that? After painting the Foxglove, the structure
of Penstemon should be easy to grasp. The main
difference between these two flowers will be the first
layer. Instead of washing over the entire flower with a
light color, we're only going to be adding color to the
tips of the petals.

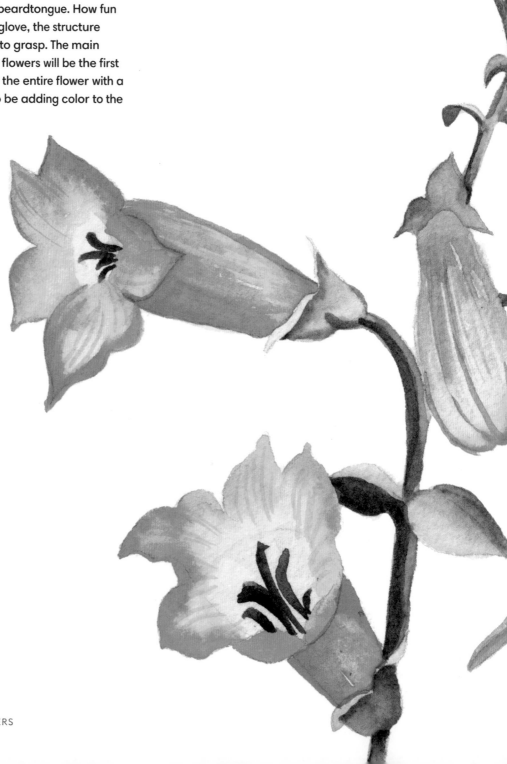

SKETCH
STEP ONE

Penstemon is similar to Foxglove in shape. Change up the angle of your stem by flipping it on its side so that we see more movement in the flowers. Draw a few blooms, in different sizes and facing different directions, then weave the stem throughout and between the flowers. If needed, refer back to the beginning of the chapter for directions on drawing bell-shaped flowers (page 88).

HIGHLIGHTS

STEP TWO

Wet your first flower, making sure not to wet the opening of the flower. Load a size 2 brush with a mixture of Opera Rose and Scarlet Lake, and add it, wet-on-wet, along the bottom edge of the flower so that the color bleeds into the water and goes from a dark value of color to gradually lighter. Repeat for each flower. For the buds, start with a really light wash of yellow-green toward the base of the bud, then apply touches of light pink and red to the top. Once the flowers are all dry, paint a light yellow-green wash over all the stems and leaves.

MIDTONES

STEP THREE

This next layer will mostly involve cleaning up edges and adding light veins and texture to the flowers.

With a darker mixture of your highlight hues, use your size 2 brush to paint thin, curved lines along your flowers to start pulling out details. Be sure to follow the curve of the bell. Add deeper color where there should be shadows, and add a midtone green to the shadow side of your stem.

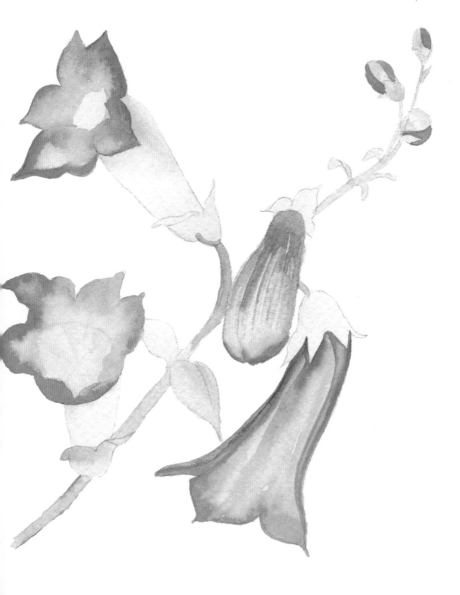

DETAILS
STEP FOUR

Add the stamen to each flower that is open and angled toward the viewer by mixing up a dark value of Mars Black and Burnt Umber. Finish up the piece by deepening vein and shadow details.

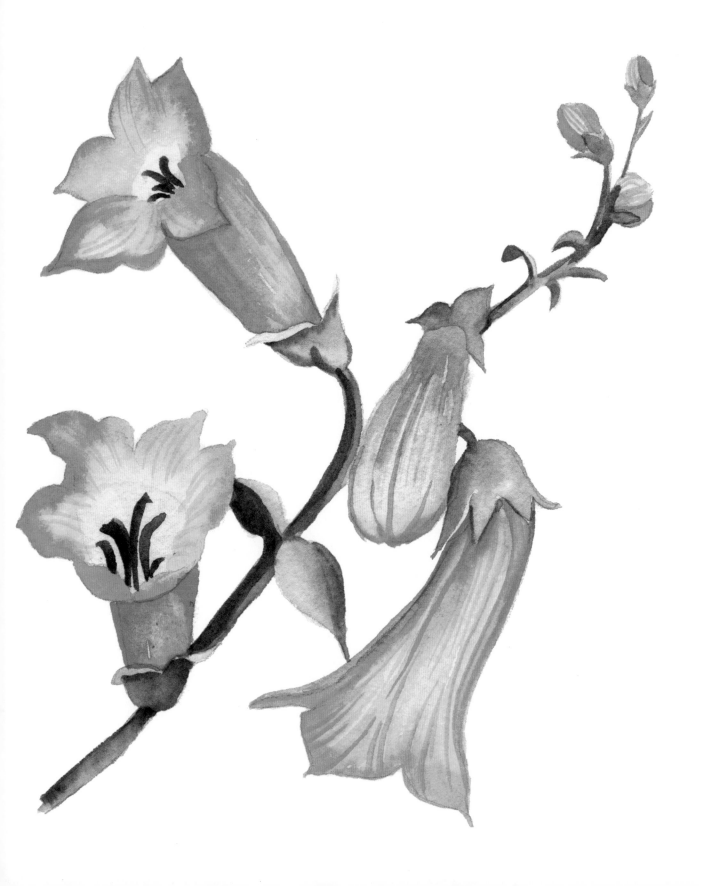

BOWL SHAPE
CHAPTER FOUR

As a natural progression in studying structure, we're going to move from the bell shape to the bowl or cup shape, which starts off very similar, but rather than following an *S* curve, the bowl-shaped flower sticks to one curve. Picture a bowl or cup when sketching or painting these flowers.

In order to sketch out the bowl shape for more realistic flowers, start with a light sketch of a circle, then add a bowl shape that wraps around the base of the circle (like the circle is sitting inside of the bowl). This is the guide for where all of your petals will go. Add petals that follow the opening of the bowl area and act as a front row of petals and then add a back row where the tops are just peeking out.

CAMELLIA
LOOSE STYLE

The camellia flower is one of my favorites to paint. At first, the shape can feel daunting and confusing. But don't worry, just like practicing anything, it takes some time to develop muscle memory and skill. Just remember to focus on creating a bowl shape with your petals, and your proportions will come out right. Once you get the hang of it, you'll be painting these flowers without even thinking about it!

POINT, PRESS, LIFT
STEP ONE

Similar to a peony, a camellia has lots and lots of petals, all growing out of a single point: the stem. Each petal should appear to originate from that point, or it will look "off."

To begin, use a size 6 brush and maybe a mix of Cadmium Orange and Scarlet Lake and complete a compound stroke starting with a vertical hold first, then changing to a slanted hold. This petal should be thin at the base, then wide and round at the top. From here, add in an arrangement of another two or three petals that vary slightly in size and color. You should have a *V* formation of petals.

BACK ROW
STEP TWO

Imagine this *V* or *U* shape as the front of a bowl held just below eye level. The far edge of the bowl is visible, poking above. Now lighten your color mixture and paint the far petals.

FRAME PETALS
STEP THREE

Once your front- and back-row petals of your camellia are painted, add in a few petals to frame the bowl shape. These side petals should seem to be falling toward you.

Fill in some of the white space around these floating flowers with stems and leaves. Imagine someone is holding these flowers by their stems, kind of like a bouquet! To create the stems, start from the middle of the flower to give the appearance that the petals are growing out from where you start. Paint each stem using a slight C curve. Once you have the stems down, place the leaves. Each leaf should feel like it's got a home base, whether the stem is visible or not. For these leaves, we'll be painting in compound strokes. Have the leaves frame your flowers by pointing them back to the center of the flower where the stem meets the petals.

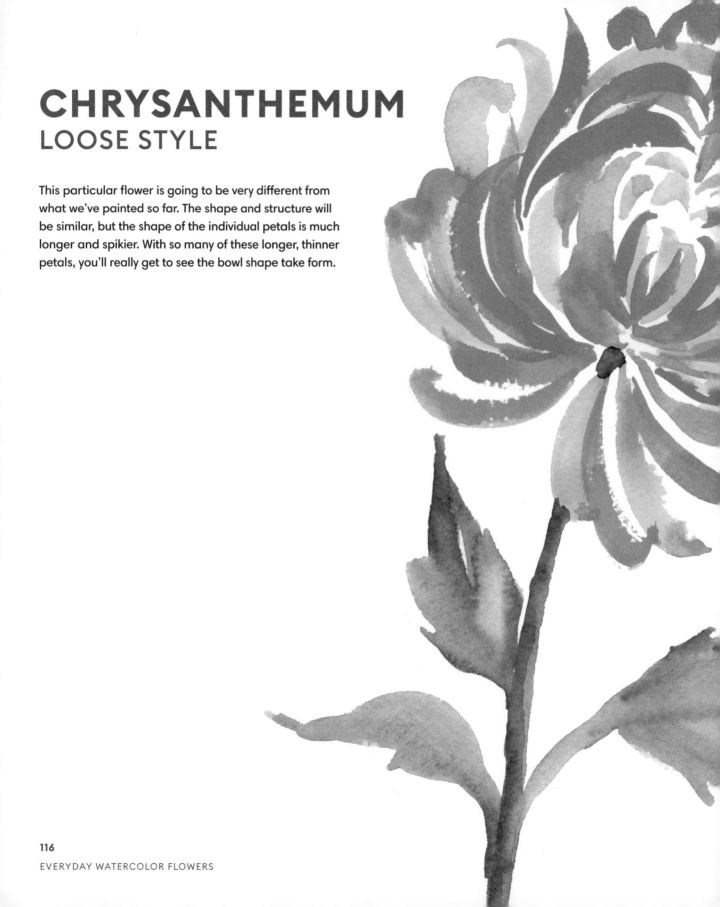

CHRYSANTHEMUM
LOOSE STYLE

This particular flower is going to be very different from what we've painted so far. The shape and structure will be similar, but the shape of the individual petals is much longer and spikier. With so many of these longer, thinner petals, you'll really get to see the bowl shape take form.

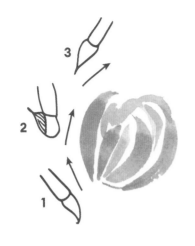

THE SPIKY BOWL
STEP ONE

We're going to apply the same overall techniques for shape that we did for the Camellia, but with longer petals. These will be painted using a size 6 brush and a mixture of Cadmium Orange and Scarlet Lake. As you paint each compound stroke, continue to point them all toward the same spot, creating the *U* shape of a bowl for the foreground petals. Make some *S* curves and some *C* curves. Add depth and variety with lighter and darker values of petals.

Start putting in the back row of petals, making them point back to where the stem will be. Leave white space between petals to show their curves and the flower's symmetry.

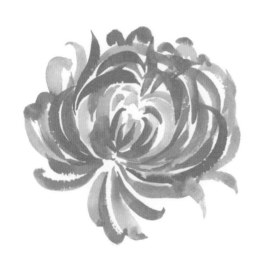

STEMS AND LEAVES
STEP TWO

For the stems and leaves, we're going to double dip! Load your size 6 brush with yellow-green, then dip just the tip of the brush into a thick mix of Sap Green. You now have two hues on your brush. Next, using a slanted hold on your brush, paint your stems, allowing the tip of your brush to create shadow on one side of the stem. Reload your brush with color when necessary. For the leaves, load up with just a yellow-green hue on your brush, and paint the leaves using compound strokes. Then extend the main stem through the leaf with a darker green on the tip of your brush to show the main vein of the leaf!

FINAL DETAILS
STEP THREE

With your darkest orange hue and using the tip of a size 6 or 2 brush, add thin petals within the other flower petals to show depth. Use a darker value to pull out vein details on your leaves to make the piece pop!

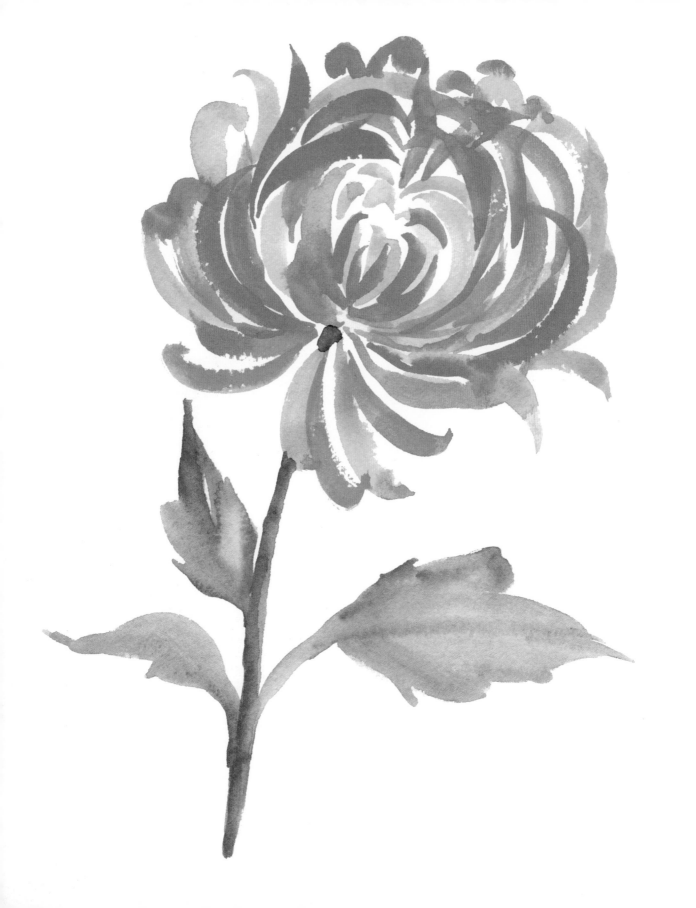

HELLEBORE
REALISTIC STYLE

The hellebore, a delicate five-petal bloom, is one of my favorite flowers. When you look at it straight on, it's star shaped, but seen from the side, bowl shaped. For this piece, the majority of our flowers will be side-facing.

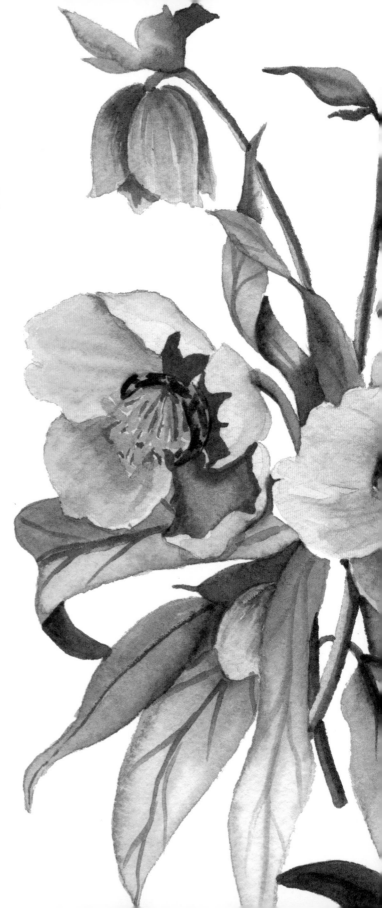

SKETCH
STEP ONE

We'll have a variety of bowl shapes in this cluster of hellebores. No need to follow this sketch exactly, have fun with yours, but always start off with a light sketch of the flower's basic shape, *C* and *S* curves for stems and leaves, and then go in and add detail and contour.

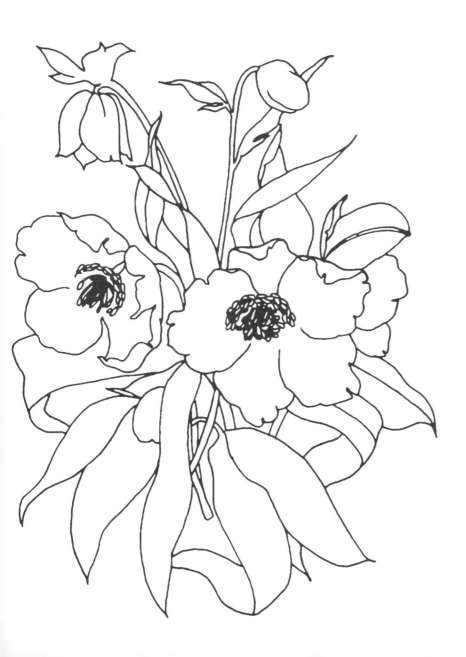

HIGHLIGHTS
STEP TWO

Hellebores, like most flowers, come in a variety of colors. For this bundle, we're going to use deep red and purple hues. So, for your first layer, apply a light wash of reds and purples all over your flowers. Apply this highlight layer even through the center of the open flowers where the stamen will go, it will be painted over later. Next, paint a light green and light yellow-green wash on all the leaves and a light brown glaze for the stems.

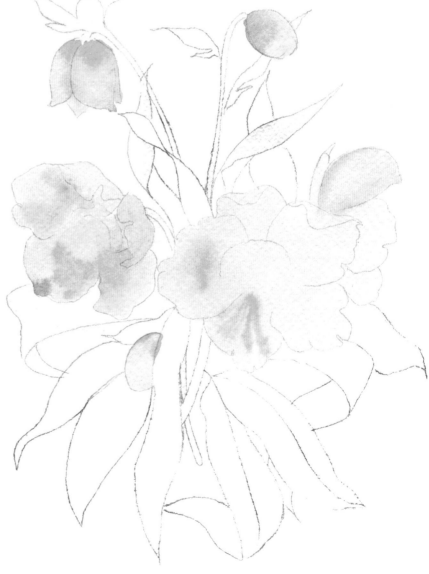

MIDTONES
STEP THREE

Once your flowers are dry, add a darker layer to the inside of petals that are facing away from the light source. Use this same color and a size 2 brush to paint vein details on your lighter petals, and use wet-on-wet technique to blend your midtone value with your highlight layer on the folds of petals. For your leaves, mix up a darker value of your highlight layer and, using wet-on-wet technique, blend this layer with your highlight areas. If there's a bent leaf, leave the curve of the leaf in highlight and apply midtones to where it curves away from the light source. Add midtones to areas on the leaf that are overlapped, to show the curve and twist of the leaf.

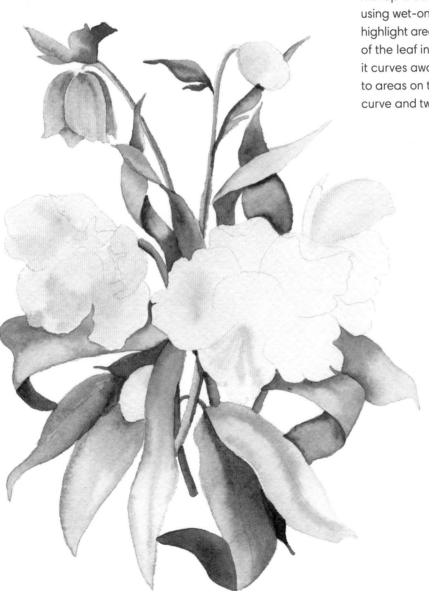

DETALS

STEP FOUR

With your size 2 brush and your deepest value of Sap Green, line the center curve of each leaf with a main vein. It's important that your vein follows the curve of the leaf. Add smaller veins along the main vein as well. If a leaf is lighter in value, make sure your details aren't too dark; you don't want too much contrast.

The two flowers that are open will have an area of green filament. Lay down a light yellow-green wash to this area, then, once this is dry, use your size 2 brush with a slanted hold and punch in darker green oval shapes. While you wait for this to dry, add shadow details to your flowers. Paint in darker veins, and pull forward any additional details in your stems and florals where necessary.

Finally, with a really thick, opaque mixture of Lemon Yellow Deep and Yellow Ocher, paint in the stamen of your two open flowers to finish up the piece.

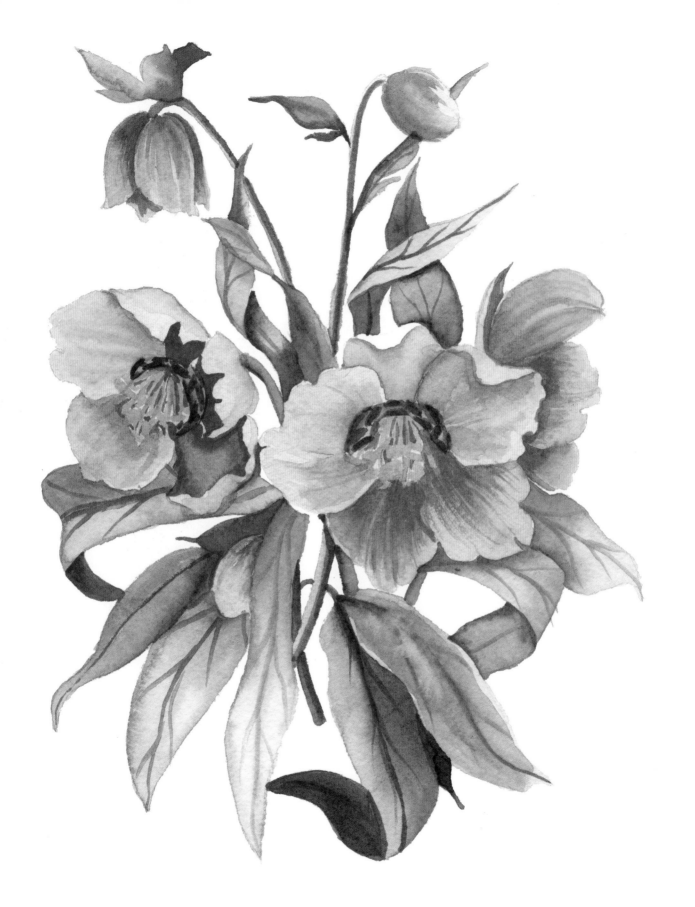

PEONY
REALISTIC STYLE

The peony . . . everyone loves this flower with its delicate texture and incredible profusion of overlapping petals. It really is a stunning flower and comes in a variety of lovely hues. With the delicate texture and tears in these petals, the sketch may seem complicated, but remember to start your sketch with basic shapes and curves, then add a more detailed contour.

SKETCH
STEP ONE

This shape is going to be a larger bowl shape, with some stamen poking through the center. If it's helpful, refer back to the looping oval trick on page 64 to make a guide for adding your petal. Next, go in and add the contour and stamen and erase the guidelines.

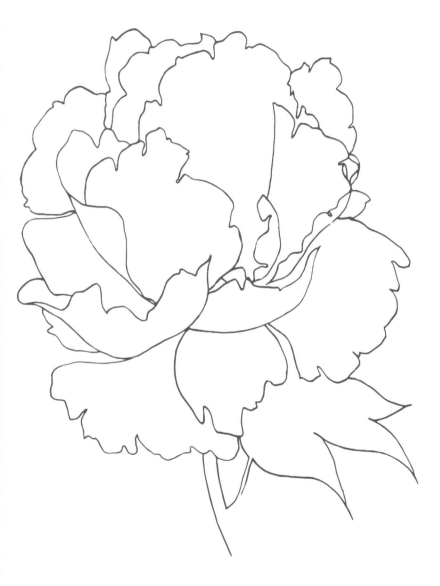

SHADOWS
STEP TWO

Yep! You read the header correctly. For this particular flower, we're going to mix things up and start with shadows! Painting our darkest values first will make it a lot easier to see the structure of each petal and how it should be shaded before we get too carried away. These shadows won't cover much area and will typically just be thinner lines in creases and folds, but I like to use this method with more delicate and intricate flowers. Additionally, this particular Peony will include more wet-on-dry technique to create texture and depth. Many watercolorists paint wet-on-dry and it's a fun way to show shadows more clearly and prominently.

For this peony, my hues are deep reds and purples, mixed up with a variety of combinations using Scarlet Lake, Ultramarine Violet, Opera Rose, Mars Black, and, for some shadows, Cobalt Blue.

Start by loading a size 6 brush with the deepest values of these red and purple colors and paint them into areas on the flower that are not being hit by light. Think about how you would shade a sphere: the base of the sphere is typically farthest from the light source, so the inner creases in the sphere of this flower and the base of petals will contain the deepest shadow values. If you miss a few shadow areas, no problem, there's always time to go back in and add these values later as well. Next, load your size 6 brush up with Lemon Yellow Deep and paint over the entire area where your stamen will go. We'll be pulling out individual filaments later, but this will be your base hue for now in this section.

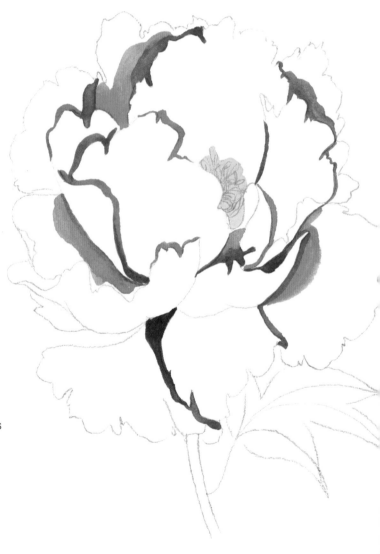

MIDTONES GALORE!

STEP THREE

If you've made it this far in the book, you've probably come to realize how important midtones are when it comes to constructing curves. If we were just to use highlight and shadow tones, there would be no smooth transition between these values, therefore no curve. Cover around half or three-quarters of each petal with midtones using wet-on-wet technique and leave some small areas untouched as bright white highlights.

For some of these petals, I've used wet-on-dry technique to show precise shadows. These hard lines make the shape of the shadow more obvious, as if a petal is casting its shadow onto another shadow.

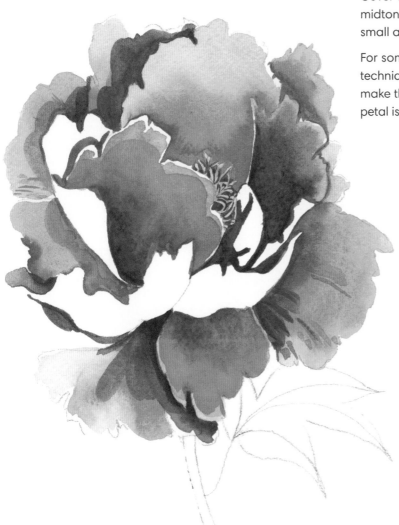

MORE SHADOWS
AND FINAL DETAILS
STEP FOUR

While the midtones from our last step dry, let's go ahead and move on to the stem and leaf. Using wet-on-wet technique, start with a lighter green value as your base for the stem and leaf, then, while that is still wet, punch in a darker value of green to the shadow areas in these sections. You can come back to this area once it's dried to add any veins and deeper shadows, if necessary.

Next, if your petals are dry, start adding veins to some of them. Here, I didn't go all out adding details to each petal, as this flower is more about precise shadows using hard edges. Add the shadows that some petals are casting on others.

Last, it's time to bring out the individual filament in our stamen area. This will be done with our size 2 brush and the darkest shadow value we've used in the flower. Make sure this color is the same as what was used to paint the petal the filaments are on top of, otherwise, it won't make sense. Use the tip of your size 2 brush to paint the tiny sections between filaments, which will look like squares. Add thin lines of petal peeking through each filament, but don't overdo it or the stamen may look too flimsy or small.

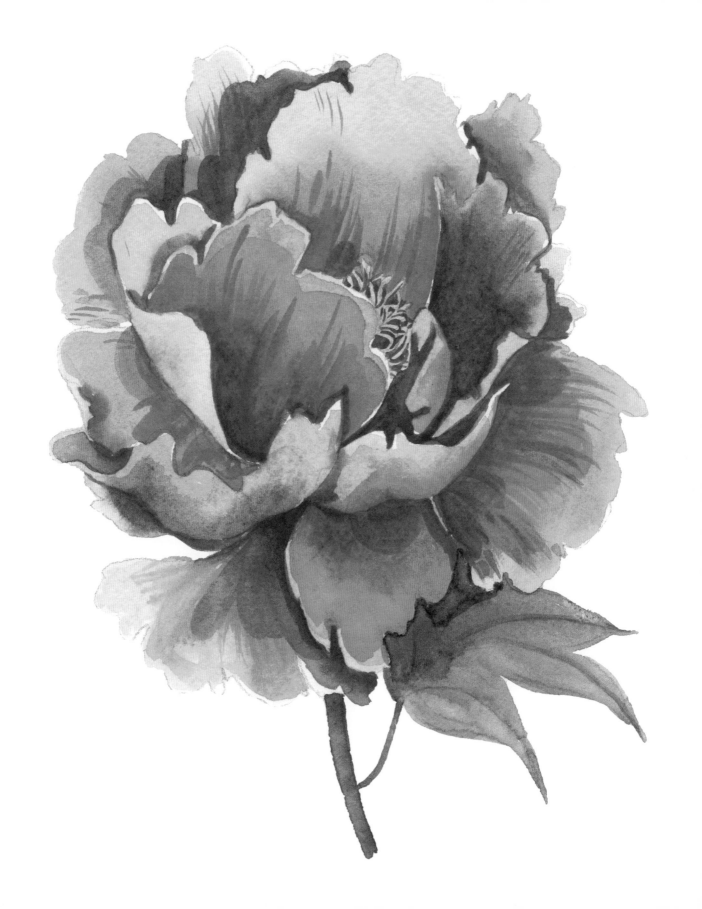

TRUMPET SHAPE
CHAPTER 5

For our next shape, we're going to be painting trumpet-shaped flowers. These are similar to bell shape, but have a thinner and longer throat and a wider mouth. The *S* curve on trumpet-shaped flowers isn't as dramatic, but the opening, or mouth, will be important. It may take some practice to get the hang of the trumpet shape, but you can do it!

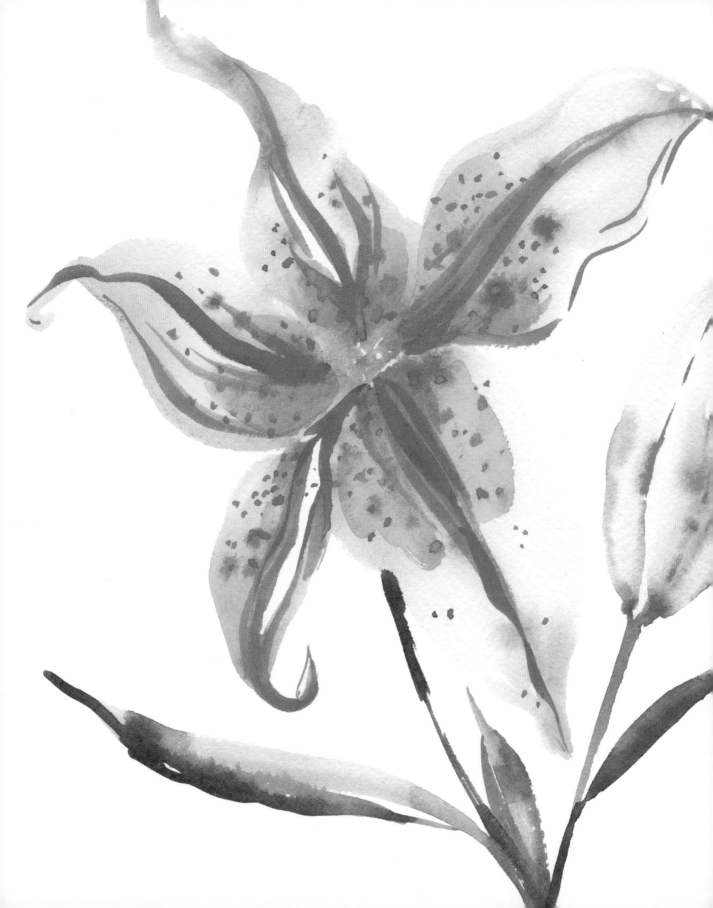

NASTURTIUM
LOOSE STYLE

Nasturtium, also known as Tropaeolum, is an easy-to-grow, edible flower. The garden at my parents' house is filled with nasturtiums, and the funky-looking leaves and bright orange flowers would often make it into salads or garnishes on drinks. It's a beautiful flower and, when viewed from the side, imitates the shape of a trumpet by growing from a point and opening up to a wide mouth. Most flowers when viewed from different perspectives will take on a different shape. For example, a nasturtium viewed straight on is a star shape, with five petals that fall out like the arms of a star. It's important that each flower be closely studied, not just its color, but its structure and shape as seen from every angle!

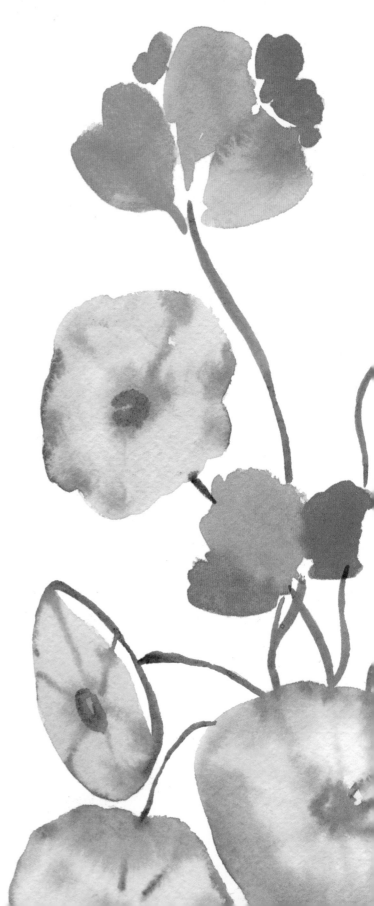

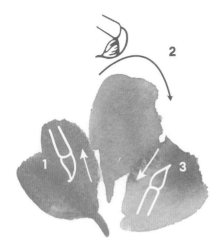

POINT, PRESS, LIFT
STEP ONE

To get started, load a size 6 brush with Cadmium Orange to paint your first petals. We're going to use the point, press, lift method we used for the Cherry Blossom (page 40), the Sunflower (page 66), and others. It's important that each petal points back to where the stem will be. As you place these petals, try to create a *V* or a trumpet shape. Paint your first petal using a slanted hold and dragging out a thin base with the tip of your brush. Next, press down, drag, and lift! Do this a few times to make the first petal a bit wider, then move on to the two other foreground petals. Slightly change the hue and value of each petal to create dimension.

BACKGROUND PETALS
STEP TWO

Imagine you are looking at a trumpet from the side and at eye level: you will only see the far side of the trumpet's opening. But if you tilt or angle the trumpet toward you just a touch, the inside of the entire opening will come into view. This is the perspective we're taking with these loose flowers.

Paint the background petals of your flower so that they are poking between and above the petals in the foreground. Create shadow and depth by making these a darker value of orange. For my flowers, I've added Scarlet Lake to my orange mixture to make it a darker, but still vibrant, color.

STEMS AND LEAVES
STEP THREE

Now it's time to get funky. Nasturtium leaves kind of look like lily pads. They're circular, their stems are wonky and bend in every direction, and there are a lot of them! Before painting in the stems, start with a very light wash or glaze of Sap Green and paint in circular shapes around the base of the piece and framing the flowers. Take care with the placement of the leaves, making sure that they help frame the flowers and that their placement also makes sense. While your leaves' highlight layer is still wet, load a size 2 brush with a darker value of Sap Green and paint the circular point on the middle of each leaf, then pull out thin lines radiating from this circle to form soft veins. Because your base layer is slightly wet, your details will have a diffused look, creating a different and fun texture. Darken the outline on some of the leaves to make them pop a bit more, then move on to your stems.

Using the same darker value of Sap Green, pull out stems for your flowers and leaves. This is a curvy and vine-like plant, so make these stems a bit wavier than in our previous pieces.

Now take a step back to look at your piece with fresh eyes and see if there are any empty spaces calling for a floral or leaf element.

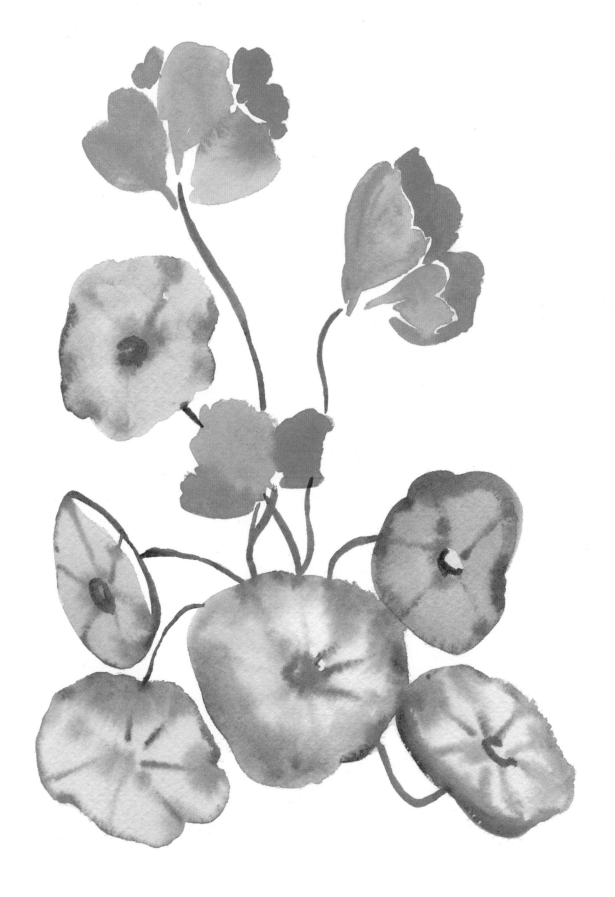

STARGAZER LILY
LOOSE STYLE

The Stargazer Lily is one of my favorite loose flowers to paint. It requires a lot of wet-on-wet for the first couple layers, creating soft blends and the spots or freckles on the petal. Embrace its unique shape while you're painting it, and make sure you're using a decent amount of water so you can achieve that lovely, diffused look!

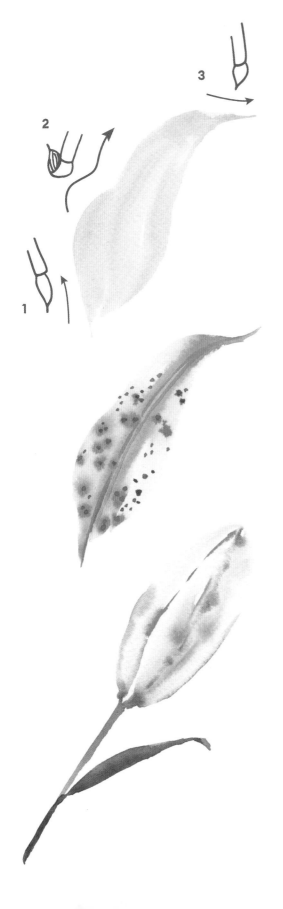

POINT, PRESS, AND WAVE

STEP ONE

For this Stargazer Lily, we'll be adding a wave to our petal brushstroke.

Start with your lightest value of pink on a size 6 brush, point the brush while using a slanted hold, then press down and, as you drag your brush along your paper, wave your brush up and down slightly to create a wave in the petal, and pull up your brush to come to a point. Complete the petal by mirroring the same stroke just next to the first so that the two points meet. Leave a thin gap between these two strokes and, with wet-on-wet technique, load up with a darker pink value and use the tip of your brush to darken the middle area of the petal. With this same value of darker pink on your brush, punch in dots around the base of the petal and watch the color burst and diffuse into the highlight layer. Follow these same steps for another one or two petals next to this one and create the shape of a trumpet. The two outside petals should be angled inward at their base to connect to the stem, creating a *V* shape, and the tips of the petals should point outward. Make sure all the petals point back to the same spot on the flower.

BUD

STEP TWO

A Stargazer Lily bud is really just a long oval. Use your lightest value of pink again to paint in an oval shape, and while the paint is still wet, use the tip of your brush and a deeper value of pink to add thin curves stretching from top to bottom on the bud. Then add touches of yellow-green to show the youth of the bud.

STEMS
STEP THREE

To paint your stems, use your size 6 brush in a slanted hold with a yellow-green hue. Make sure the stem has some curve and always points back to where the center of the flower would be. Begin to pull your curve from the base of your petals, connecting the point of petals and stamen on an open flower. This will ensure the petals are growing out of the stem.

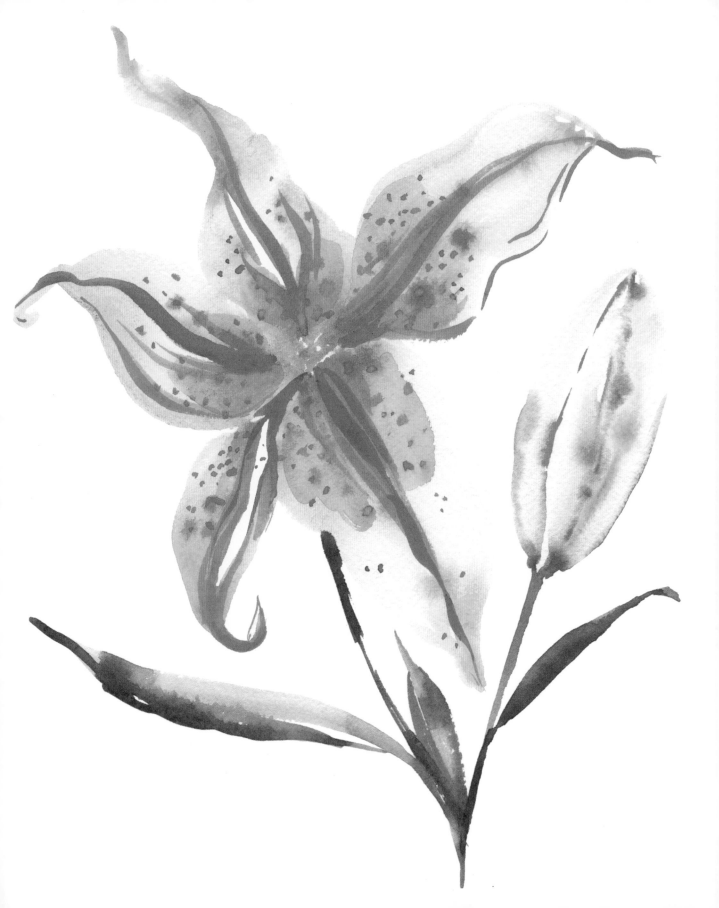

MORNING GLORY
REALISTIC STYLE

My mom has always affectionately called this flower
or vine a weed. Once planted, it grows rampantly,
curving and slipping through cracks in fences, climbing
walls, and covering yards with its trumpet-shaped
flowers.

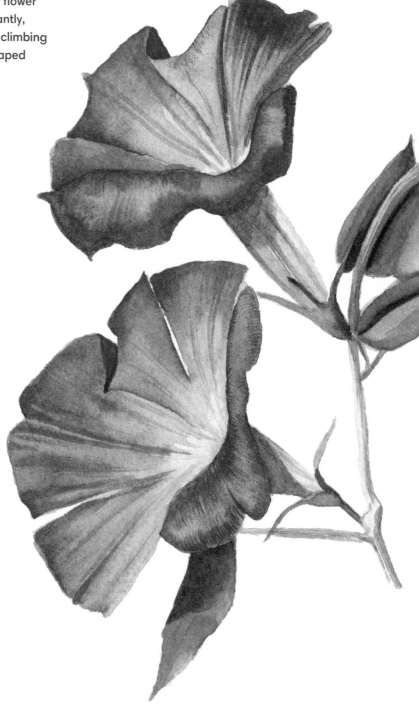

SKETCH
STEP ONE

For this sketch, we have two trumpet-shaped main flowers viewed from the side, a stem, and surrounding leaves.

To start, lightly sketch in basic trumpet shapes. The main feature of this flower is the mouth of the trumpet, so make this circular shape much wider than the cone base, then develop the contour and detail.

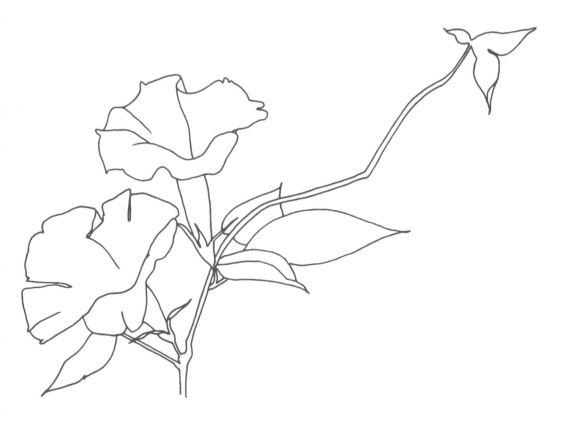

HIGHLIGHTS
STEP TWO

For the base hue of our Morning Glory, we're going to start with the belly of the trumpet. We'll be painting the belly down to the end of the petals a deep purple. But for the part of the flower from the sepals to the belly of the petals, we'll need to achieve a white effect and will only paint shadows on this part of the flower. In this case, the shadows will be a mixture of Cobalt Blue and Mars Black, Ultramarine Violet and Mars Black, and on the right side, where the light source is, we'll punch in a light wash of yellow. We'll begin with the lightest mixture of these hues for our highlight layer.

Start by painting the morning glories' throats with your purple shadow hue, then move to blue, then add in yellow minimally on the right side. While that dries, move on to the stems and leaves and lay down your highlight hue using a light Burnt Umber for the stems and a light glaze of Sap Green for the leaves.

The throat of your flower should now be dry, so you can paint the mouth of each flower. Use a very light value of Opera Rose and Ultramarine Violet to wash over the entire mouth of the flower, then while this is still wet, punch in a darker value to the outer rims of your petals. Your darker value should bleed and diffuse into the lighter, creating a gradation of dark to light. The stem end of this flower is white while the petal edges are deep in color, so if your color is starting to bleed too much, make sure to have a dry brush or paper towel handy so that you can help control this or soak up the color.

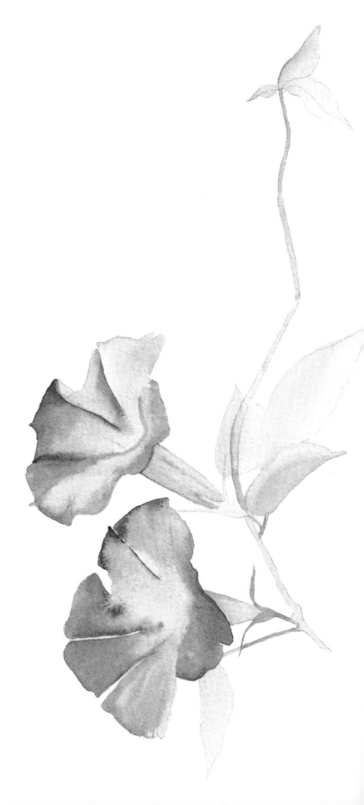

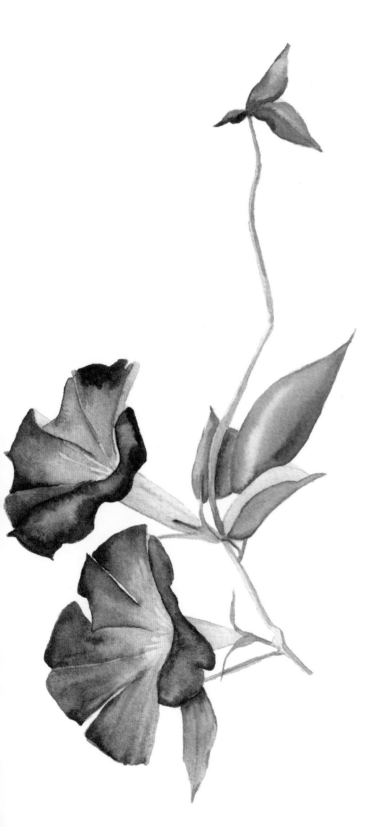

MIDTONES
STEP THREE

Next, it's time to pull some details forward in these flowers. Use a size 2 brush and a slightly darker value of the colors you used in your highlight layer and pull out folds and crease details in your flowers. These are midtones, so try not to make them too dark in comparison to the value of your highlight. The change in depth from highlights to midtones should be gradual. Add multiple midtones on each petal, and if there's an area on the petal that calls for more depth, like a petal overlapped by another, darken up your mixture slightly. But don't create too much contrast just yet. Accentuate the curve on the part of the petal that's curled out, by adding details along the edges of this section that follow this curve, and leave a highlight in the middle. Think of how a cylinder curves and how this shape would be shaded. That is essentially the shape of this part of the flower. Leave the belly of the curve in highlight to show that it's closer to the light source. Next, darken up the sides of the stems and leaves that will be in shadow, but leave the opposite side bare, with the highlight layer showing.

SHADOWS
STEP FOUR

Now it's time to bring the final details forward to create a pop! Mix up a Cobalt Blue and Ultramarine Violet hue that's a shadow value and paint the shadow cast by the mouth petals on the flowers' throats. Next, with your darkest Sap Green and Burnt Umber values, add details to the leaves and stems.

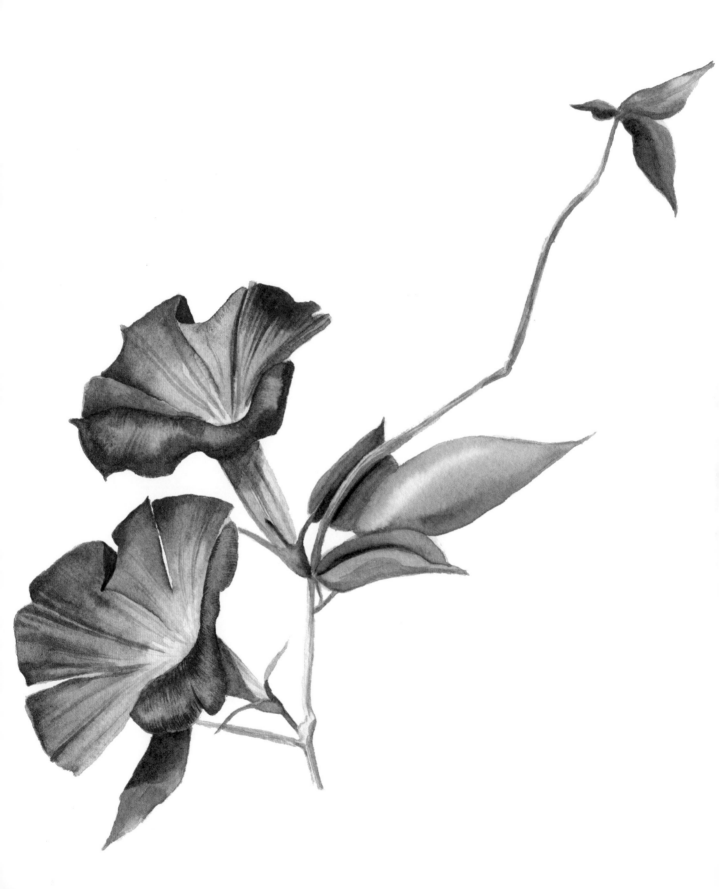

AGAPANTHUS
REALISTIC STYLE

Agapanthus, or Lily of the Nile, is quite a common flower around where I grew up. From far away, the crown of the flower looks like a firework, but when you get up close, you see the crown is composed of multiple mini trumpets.

SKETCH
STEP ONE

Have patience with this one. Because there are so many little flowers, it can seem daunting, but just remember that each flower is a tiny trumpet on a stem that leads back to the main stem. Start by sketching those basic shapes first if you need to, then add the contour and the small stems. Sketch in buds shaped like the Stargazer Lily bud we painted, have some trumpets pointing up to the right, some straight on, etc., to show perspective. They should point in different directions to add depth and detail.

HIGHLIGHTS
STEP TWO

Because these flowers are a bit smaller than others we've painted, use a size 2 brush to paint the highlight layer. I've used Ultramarine Violet with a touch of Cobalt Blue, with some flowers using more blue than others to mix it up and show depth. Make sure you don't have too much water on your brush, as it can be hard to control in some of these smaller, tighter areas. Once you've finished the first layer on all of your flowers, move on to a yellow-green wash on the leaves, then move to the stem, being sure the flowers have dried before you add the stem.

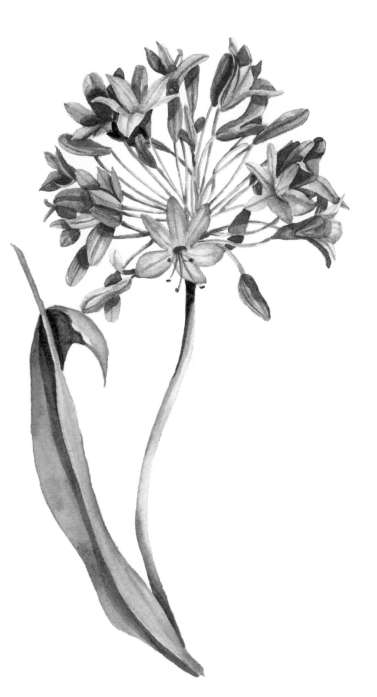

MIDTONES
STEP THREE

Midtone layers are essential for showing curve and form. Apply a thin wash of a midtone hue along the edge of each petal, then, with water only on your size 2 brush, massage and soften this color into the highlight layer so that it stays dark around the edge but gradually softens as you work your way to the inside of each petal. Next, add a thin line of color down the middle of petals that are facing forward to accentuate the midrib.

Now start adding shadows on the midrib or middle of the flowers and on the base of some of the flowers, where the petals are casting a shadow. This will help your eye catch where areas need to stay highlighted and the areas that will call for deeper shadows in the next layer.

Paint in your midtone layers on the stems and leaves, emphasizing where the flower would be casting a shadow on the stem and using shadow to create overlapping.

SHADOWS AND DETAILS
STEP FOUR

For this next layer, create more depth with your darkest values of purple and blue on the flowers, your deepest value of green on the stems and leaves, and send shadows even deeper by applying a Cobalt Blue wash over them. This will help cool them down, and, if you think about it, shadows are spots far away from the light source, which is usually a warm light. This cool color will help make your shadows feel deeper.

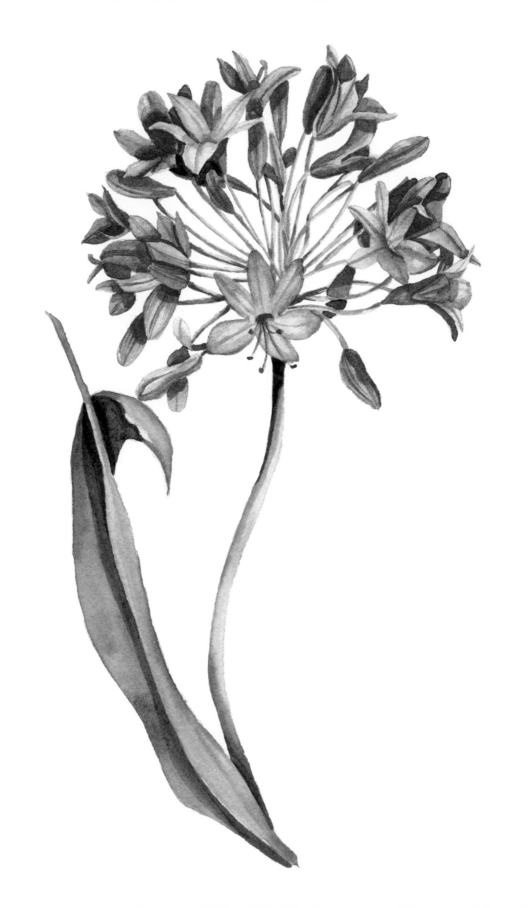

COMBINATION
CHAPTER SIX

We've officially come up to the final shape we'll be covering in this book, the combination shape: a flower that combines the shapes we've already covered. For example, the Bearded Iris has a bowl shape on top with a star bottom half. The Coneflower is a sphere shape for the disk area with another upside-down bowl shape for the petals. For each one of these flowers, we will continue to incorporate the techniques we've been practicing up until now. It's time to switch things up a bit and put your eye to the test!

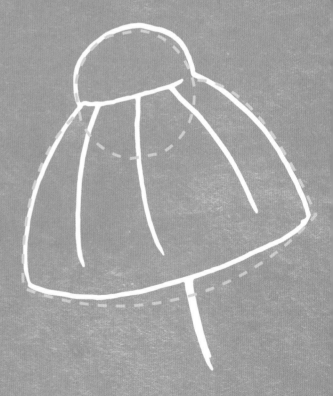

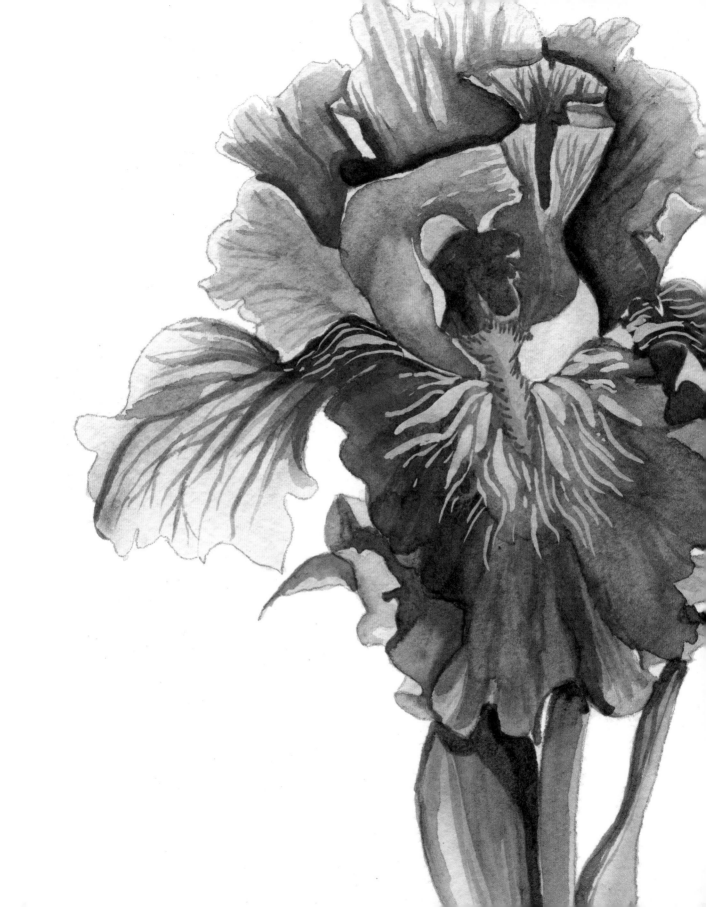

SWEET PEA
LOOSE STYLE

This flower reminds me of tissue paper. It is so dang delicate. We're going to keep the overall structure of this flower relatively simple, focusing on its combination of a bowl and a trumpet shape to help us place our petals.

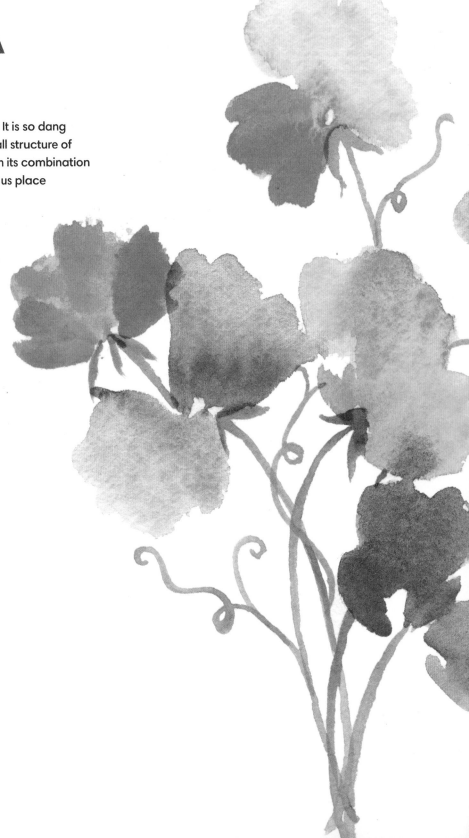

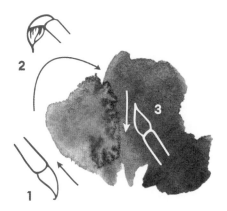

POINT, PRESS, LIFT
STEP ONE

We're going to paint Sweet Pea petals much as we've painted other loose-style flowers, but with a slight twist. Before you start painting, let's take a closer look. Sweet pea petals look like pinched tissue paper or a dainty flamenco skirt that's being lifted and spun. To capture the essence of these petals it's important to keep your strokes loose. But make sure that each petal points back to the same spot on the flower.

To start, load your brush up with a light value of Opera Rose and a touch of Lemon Yellow Deep, or if you'd like to paint a purple sweet pea use Cobalt Blue with a touch of Ultramarine Violet. Once you have your color mixed up, with an angled hold and a size 6 brush pointing toward the base of where your petal will be, press down, drag your brush up a bit to make this stroke longer, and lift directly off the paper. You should have a teardrop- or oval-shaped stroke. Add to this with two to three similar strokes that vary in height, but all connect at the base. Vary your sweet peas in size and also in the number of petals showing—some will have two petal strokes, some just the one, but when painting an entire stem, keep the flowers very light and place them on the stem at different angles so that they appear to dance around the stem. Change up the values and hues from flower to flower, just as they would appear in real life when hit by light. This also helps the piece not feel flat.

STEMS
STEP TWO

While some of your petals are still wet, paint in your stem with a size 2 brush and a light yellow-green. Connect your stem to your flowers and allow for the yellow-green to bleed into some of these wet petals to create a fun color-blending surprise!

CURLY STEMS

STEP THREE

With your size 2 brush and the same yellow-green mixture, paint in stems that bend and curve around the main stem and flowers. Sweet peas have this wonderful, wiry element to them with stray stems bending and weaving around the flowers. It's amazing! So add these to create more movement and detail!

Sweet peas come in many colors and varieties, so pull up some images for inspiration and paint a few for practice.

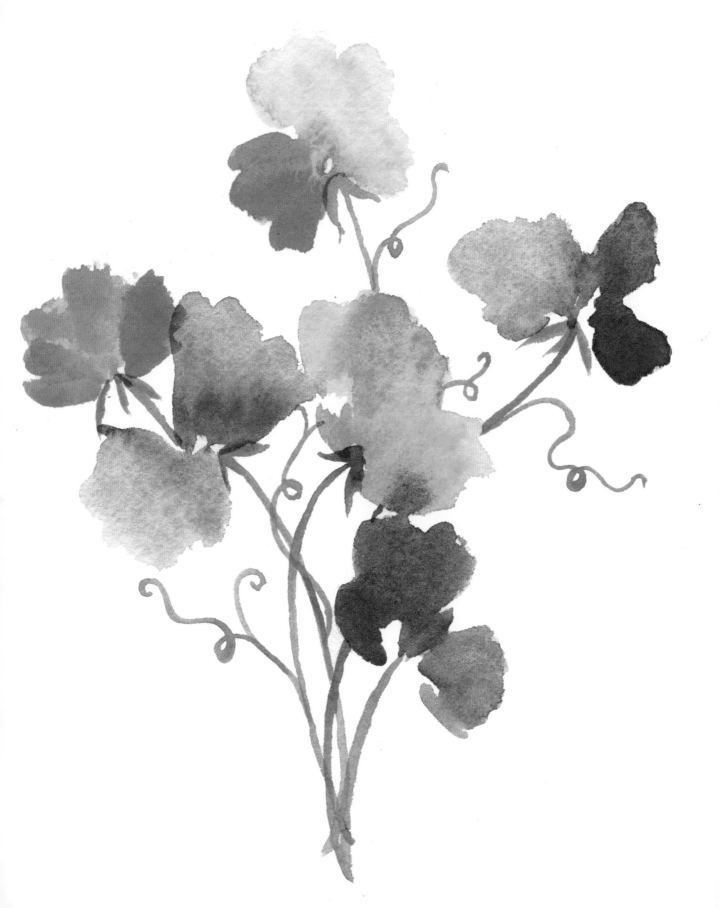

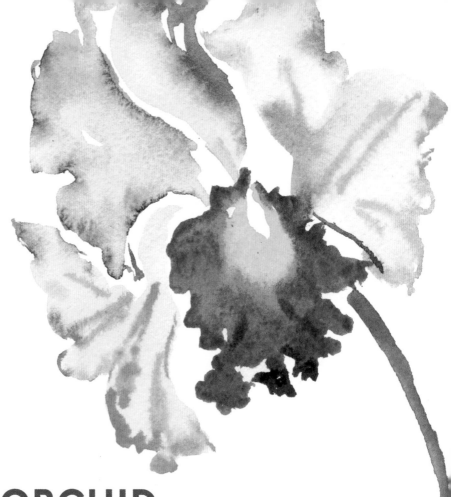

ARUNDINA ORCHID
LOOSE STYLE

This particular orchid has white or pink star-shaped sepals that frame the ruffled magenta-edged labellum (lip). This labellum is shaped like a trumpet and has a deep-yellow center. It's a beautiful flower and so much fun to paint in a loose style.

POINT, PRESS, AND WAVE
STEP ONE

Start this flower with the lip: Mix up a very deep and vibrant combination of Opera Rose and Ultramarine Violet. Once you have your color mixed up, load a size 6 brush and, with a vertical hold, start with the point or tip of your brush and drag a little bit, then apply pressure so that the hair of the brush fans out. Now wave your brush along to form the wavy texture of the edge of the labellum. Continue doing this all around the shape of the lip, which, when viewed straight on, is an oval; then bring the stroke back to where you started and meet with a point. Make sure you leave an opening at the top, kind of like a bib, then load up with Lemon Yellow Deep and punch this color into this opening.

SEPAL AND PETALS
STEP TWO

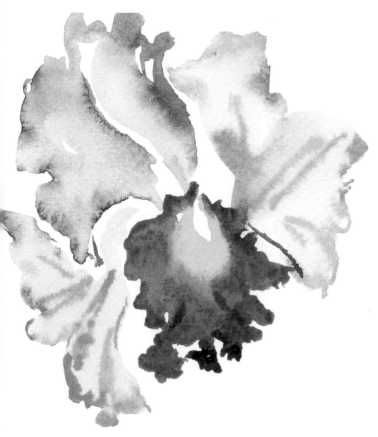

Move quickly from painting the labellum to the petals and sepal so that you will get some fun bleeding of colors. Completely wash off the color you used for the labellum and load your brush with clean water. With a slanted hold, point the tip of your brush toward the center of the flower, or the top of the labellum, and drag out one of your petals, putting pressure on the brush and waving it. You will be creating three separate petals that sit like a crown on top of the lip of the flower. Your two outside petals should be mirror images, pointing back to the center of the flower, while the middle petal should be pretty much straight up. After laying down just the water for your first petal, go back and add thin lines of pink and purple hues throughout the petal to show shadows and folds using wet-on-wet technique. Keep this simple and don't overthink it so that the petals will remain delicate and soft.

STEM AND LEAVES
STEP THREE

For your stem color, mix up a vibrant hue of yellow-green. The yellow in this mixture is going to help accentuate the purple in the lip of the flower, as yellow and purple are complementary colors. Paint your stem using your size 6 brush and a slanted hold. Hold your brush perpendicular to the direction of the stem and use the belly, not the tip, of the brush. Next, paint a few leaves, making them a bit larger than the compound stroke leaves we practiced earlier (page 34), but use the same steps.

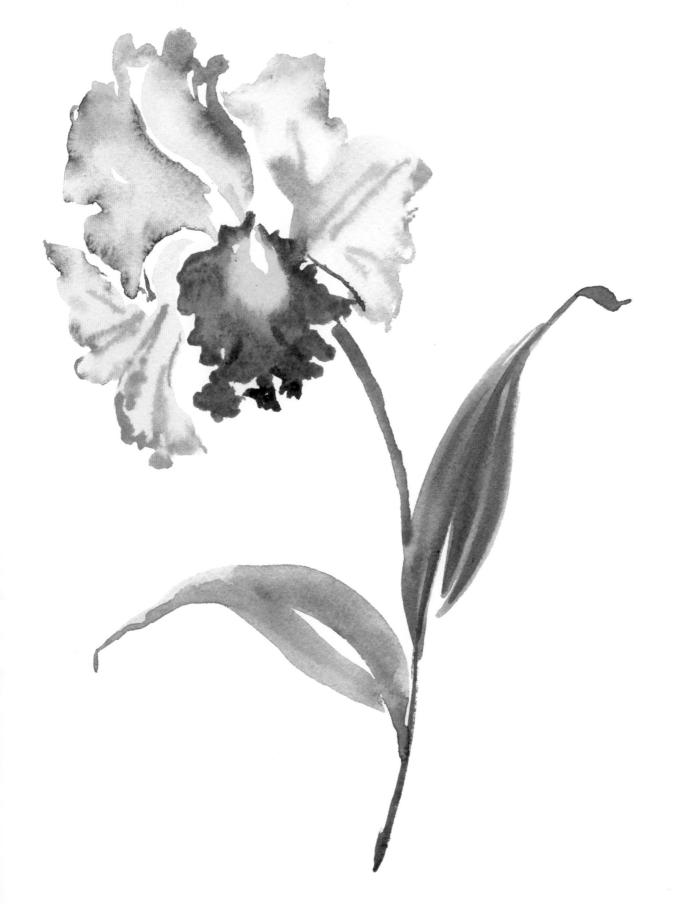

BEARDED IRIS
REALISTIC STYLE

The iris has been painted by many famous and incredible artists, including Vincent van Gogh, Cézanne, and Leonardo da Vinci. This flower comes in many shapes and colors from deep, deep purples and indigos to taupes and peach, truly an incredible flower. I am especially fond of the Bearded Iris. The petals are much larger than those of the Dutch Iris and there are two distinct parts to this specimen. The bottom petals replicate a fan shape with the top petals being a cone or bowl, and the texture and folds are to die for, like a dancer wearing a fabulous skirt.

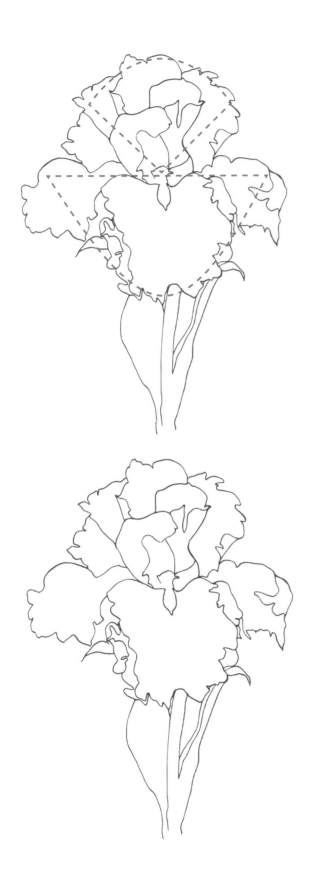

SKETCH

STEP ONE

We're going to start out with a very light pencil sketch. Using your sketching pencil, lightly draw the outline of a cone for the top petals and a fan for the bottom as a guide. Then add lines indicating where you'd like the stem and leaves to go. Next we'll develop the contour.

The Bearded Iris is quite curvy and textured. Picture a flamenco dancer's skirt, the flaps and folds . . . this is the essence of what we're trying to capture in these petals!

HIGHLIGHT LAYER
STEP TWO

Now that we have our flower outlined, with all its curves and folds, it's time to lay down the highlight hue for each section. Every petal, stem, and leaf is going to vary in hue and depth. For example, the bottom part of the flower is going to appear more vibrant and full of color while the top half, or bowl shape, is going to be more translucent and light. With this in mind, the bottom petals will have a highlight that's slightly richer in color than that of the petals that are the crown of the flower. This is generally the case for all Bearded Iris flowers and will apply to the flower we're painting today. So, using a light wash of Ultramarine Violet and some Cobalt blue, cover the entire flower with a highlight layer. Punch in yellow where there's a small section in the middle of the "beard" of the flower for some wet-on-wet blending of yellow and violet. Once your petals are dry, move on to the highlights for the stem and leaves using yellow-greens and mid-greens made with varying mixes of Lemon Yellow Deep and Sap Green.

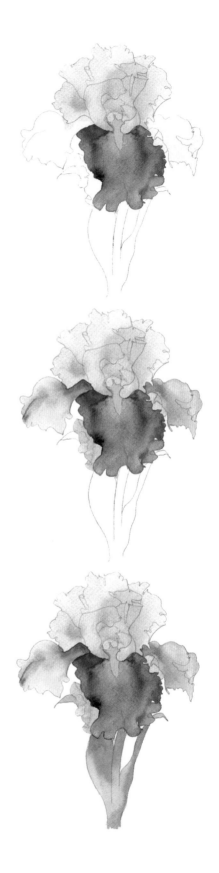

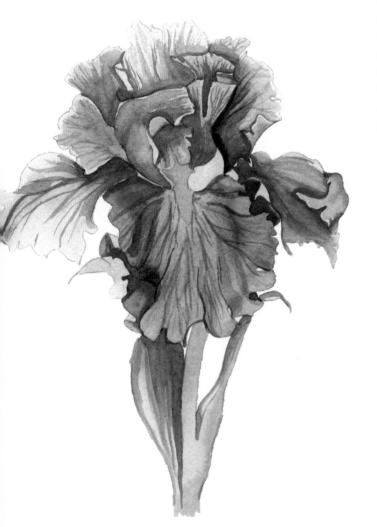

MIDTONES
STEP THREE

Once your highlight layer has completely dried, start working in some detail and midtones. Start with the bottom foreground petals. These petals should be richer in color and detail, so I usually like to start with them and get the hang of how I will be detailing the petals before moving on to the lighter top petals. Use the point of a size 2 brush to pull out veins and soften them by washing over them or using the dabbing technique to lift color. Apply the same techniques to the stems and leaves, deepening the base hue for midtones and beginning to add light details and veins.

SHADOWS AND DETAILS
STEP FOUR

Use your darkest hues for the shadow; make the petals in the back recede by making the base of each petal darker. Next, accentuate the edges and vein details in the petals in the foreground. Using your shadow green mix, apply your darkest tones to show a shadow cast by the petals on the stems and leaves, and either brush it out with a dry brush for texture or dilute and soften the edge with water.

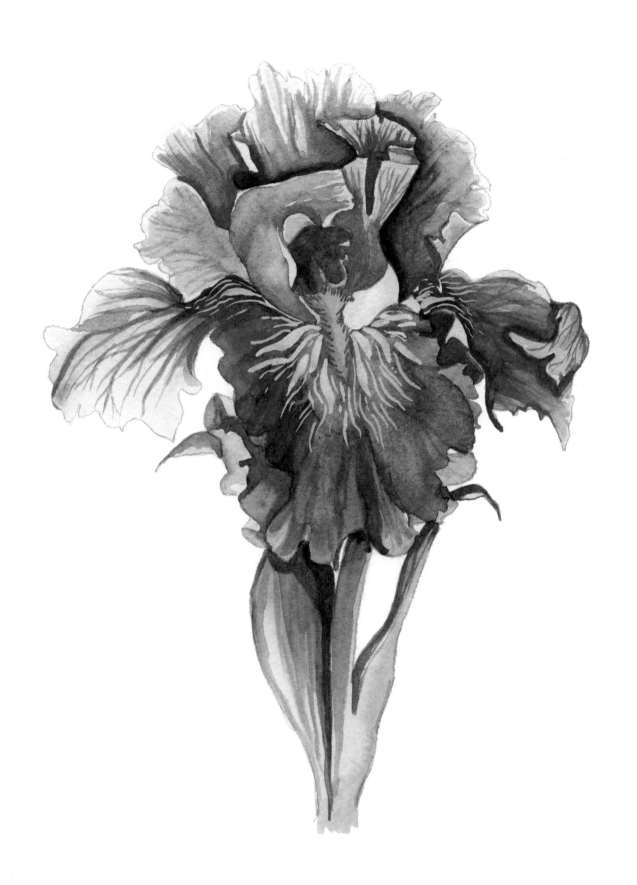

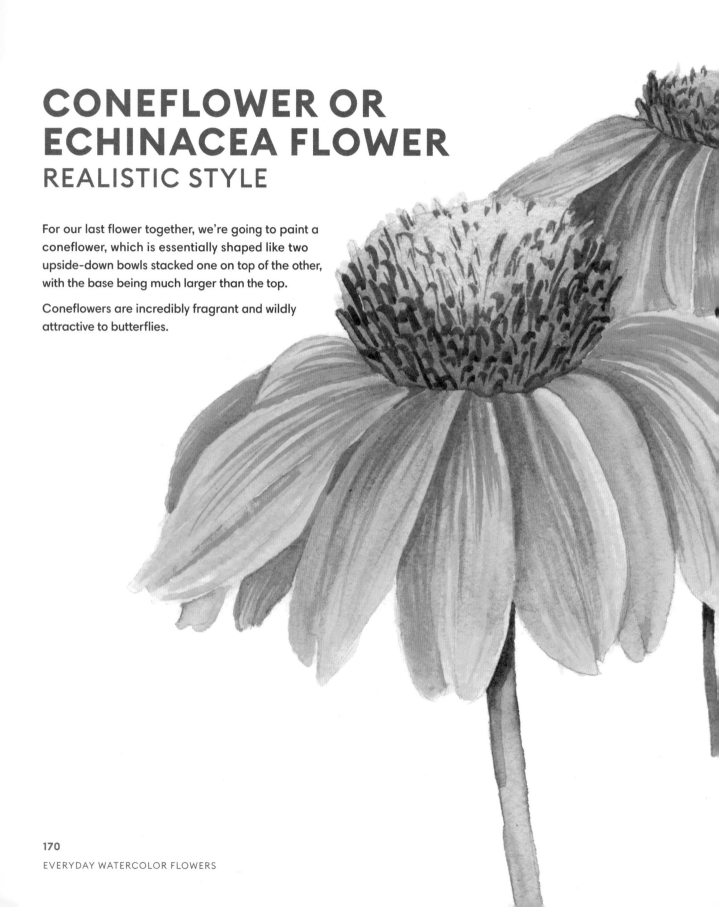

CONEFLOWER OR ECHINACEA FLOWER
REALISTIC STYLE

For our last flower together, we're going to paint a coneflower, which is essentially shaped like two upside-down bowls stacked one on top of the other, with the base being much larger than the top.

Coneflowers are incredibly fragrant and wildly attractive to butterflies.

SKETCH
STEP ONE

For our sketch of the coneflower, we're going to start with a sphere for the top of the flower, then draw an upside-down cone that connects about halfway up that sphere. This will be our reference guide for the contour of the flower, so as usual, make sure to sketch this very light and loose. Then from here, observe the details and curves of each petal and the stamen in the flower, following the overall shape of our sphere and cone. Once you've added the details and contour of the flower, erase any guides and lines you don't need before you start painting the first layer.

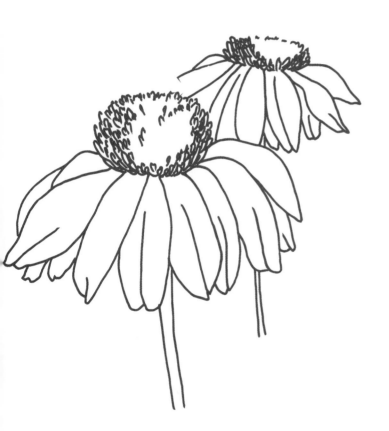

HIGHLIGHTS
STEP TWO

Load up a size 6 brush with a light value of Opera Rose and Yellow Ocher and glaze over each petal. Alter the hue slightly, petal to petal, so that there's some movement and not too much redundancy. While the flower in the foreground is drying, move on to the background flower and paint in the mound area, using a size 2 brush, with a light glaze of Burnt Umber at the base that fades into Yellow Ocher and Lemon Yellow Deep to show how it curves. Move between the flowers, painting their base layer and making sure to not paint sections that are touching others that are still wet.

MIDTONES
STEP THREE

Using your size 2 brush and slightly darker values, carefully place your midtones. Show that petals overlap by darkening the edge of a petal that's right up against another. Add a deeper value of Sap Green to the parts of the stems that are right below the petals, showing shadow.

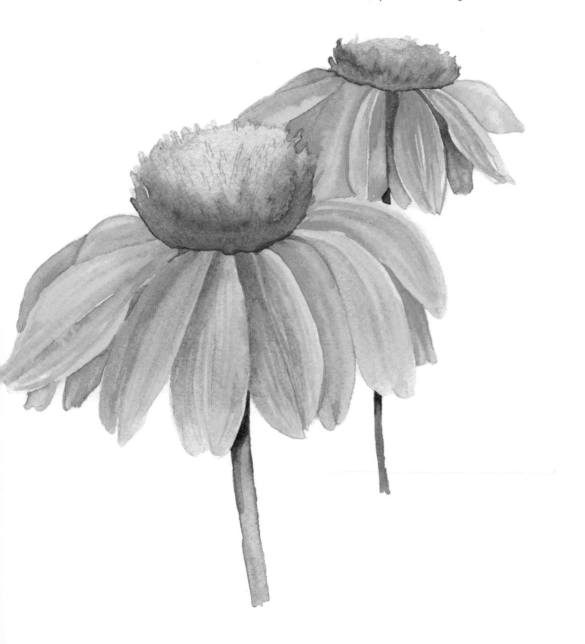

FINAL DETAILS

STEP FOUR

Pull out smaller details with your size 2 brush using your darkest values. For the mound, or disk, of the flower, use a mix of Burnt Umber and Yellow Ocher to paint the outlines of the filament area. To show dimension and curve on this surface, add more detail toward the base of the concave surface, then, as the color fades to yellow, add fewer and fewer details. Add thin vein work to the petals, curving them to follow the flow and accentuate the hue of each petal.

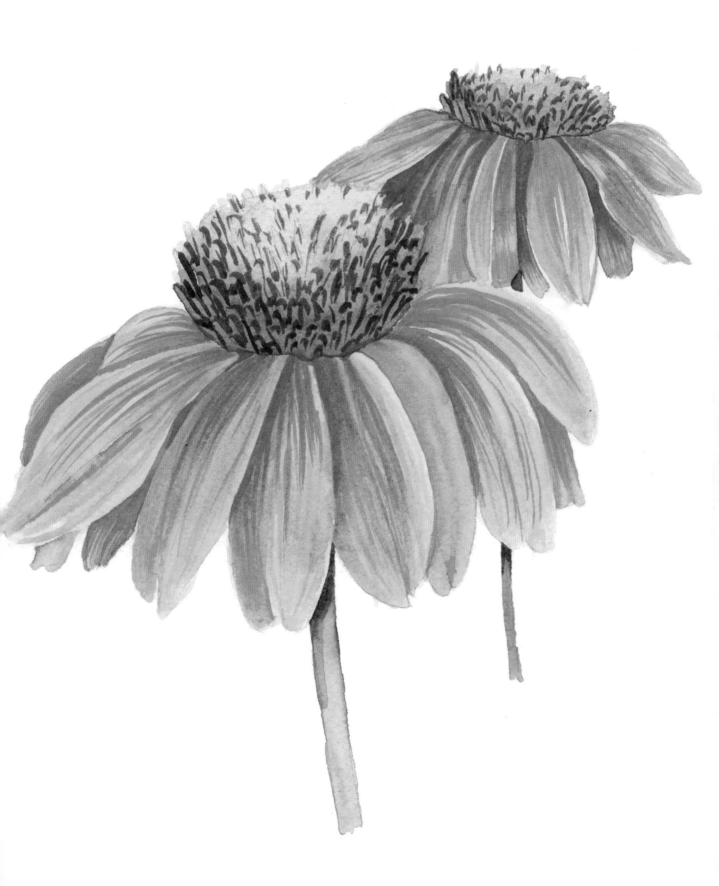

AFTERWORD: PUTTING IT ALL TOGETHER

Now that we've learned how to analyze some basic shapes of flowers and paint them in both a loose and a realistic style of watercolor, it's time for our final project together. Loose watercolor can be challenging for some, so I think it's important to revisit some tips as we work on a wreath or floral frame and a full garden piece. It's important during these pieces to focus on SHAPE. It's easy to get lost when you're creating a floral composition, so remember to stay loose.

For this project, we're going to paint a full floral explosion (see opposite page). It's easy to become overwhelmed by the amount of white space there is to cover up with florals, but just focus on the shape of each individual flower and create movement within the composition. To create motion, imagine chucking a bunch of flowers into the air and see how they land on your paper—loose, random, and explosive. All of your fluffy Peonies will be bowl shapes, add berries by doing loops and strokes similar to the Bluebell, and Agapanthus petals will just be upside-down teardrop strokes. Curve leaves in different directions and make sure each and every petal and leaf is pointing back to where it's growing from: its stem.

With all of these pieces, use color to create harmony. Complementary colors will help draw your viewers' eyes in, but make sure one of the complementary colors is more dominant than the other. For example, in the floral explosion piece, opposite, there are orange accents in berries and buds, while the blue in the Agapanthus and some leaves is more dominant. It's all about movement and drawing eyes in with shape and color.

For the floral frame piece on page 179, I started with the bigger floral shapes first. This helped direct me where to go with my smaller details and dashes to create fuller shapes. Again, I've used complementary

colors throughout this piece, orange and blue, reds and greens, making sure that one or the other is more dominant in order to create more harmony and less competition or strain. Dashes or sprigs are a fun detail that helps direct the movement of the piece. Just use your size 6 brush and put a little pressure on the tip, then drag the mark in a straight line.

For the final floral project on page 181, we're going to get a bit more detailed! Apply what you learned about floral shapes by lightly sketching out spherical and cone shapes for these flowers, then adding in the contour, leaves, and details. The color palette I chose for this piece is more on the contemporary side, with sunset colors for the florals. I wanted some contrast, so the leaves are a blue-gray made from Phthalo Turquoise, Mars Black, and lots of water. This muted blue provides contrast to the warm colors, especially the orange and peach in the flowers. One thing I kept in mind for the composition of this piece was the zigzag rule. If you look closely, the points of interest bounce around the piece in a zigzag. For example, the berries start in the top right, then slightly lower on the left, then bottom right. This leads your eyes across the entire piece, which wouldn't happen if all the berries were in one area. Also make use of odd numbers with the majority of your elements. When there are even numbers of elements, viewers tend to look for pairs rather than moving through the piece. Odd numbers will keep them looking longer.

Keep practicing! I know that gets really old to hear, but it's just like anything. If you want to run a marathon, it doesn't matter if you have all the right gear, best shoes, outfit, etc. If you don't train, you will not succeed or see results. The more you practice and put time in, the more growth you'll see in understanding color and shape and forming muscle memory! So, these last pieces are geared to help you develop your own style and put all the knowledge on shape and color covered in the previous pages to use. There's no step-by-step instruction, just an overall guide so that you can put everything you've learned into practice on your own. If you don't like how your first few attempts turn out, that's normal. My first floral watercolor paintings sucked! That's just how it goes. So keep trying new things and going back to the drawing table!

CONCLUSION

The paintings in this book may be all done, but that doesn't mean you should stop painting flowers in this way. I hope this book and your study of flowers' basic shapes have challenged you and made you more observant of how things are structured. This way of painting not only helps you grasp the right proportions and dimensions, but also turns you into someone who looks longer at things. When you are next in the garden or out in nature, stop and look at the flowers. What shape are they? Do the leaves follow an S curve or a C curve? From what angle are you viewing the flower? Study the details in petals, the fuzzy texture on the stamen, and take note of the hues and color combinations you find.

I hope this helps you slow down and observe, develop patience with the process and with yourself, and, in the end, become a better painter. Don't get discouraged when you make mistakes, be grateful. Each mistake is helping you become that much better at your craft if you're able to learn from it. I challenge you to find a new flower for each shape covered in this book and paint and sketch it on your own! If you're on social media, Instagram has become such a great community for sharing your work and encouraging other artists, so make sure to hashtag #EverydayWatercolor when you post your work to stay inspired and longing to paint more!

ACKNOWLEDGMENTS

Writing a book is much harder than I ever thought but the most rewarding thing at the same time. Thanks to the humans below who encouraged me, stayed up late with me, were patient with me . . . this collection of pages wouldn't have been possible without you.

To my husband, John, the person who knows me best, challenges me the most, and brings out the best in me always.

To my parents, who instilled creativity and imagination in me and encouraged me to go outdoors as a kid, you've taught me so many lessons about art, business, and life that I don't think you even know!

To my girl Brooke Dieda, who's been my right hand in business and now life, taking on extra work loads from me when I've been swamped with these crazy book deadlines!

I would also like to thank my agent, Kimberly Brower, my editor, Lisa Westmoreland, and the rest of the team at Ten Speed Press, this book would be riddled with spelling and grammatical errors and wouldn't even exist without you!

ABOUT THE AUTHOR

Artist and influencer **Jenna Rainey** inspires a generation of creatives to make art every day, even if it sucks. Never expecting to follow in the footsteps of her artist mom, within five years, she turned her creative talent into Jenna Rainey Design Studio, through which she licenses her vivid hand-painted designs to some of her favorite lifestyle brands. Today, Rainey brings her carefree attitude about art and her personable style to workshops around the world, online tutorials, and Instagram, where she has a growing fan base of 160K-plus. She is the bestselling author of *Everyday Watercolor* and keynote speaker at leading design summits. Follow her @jennarainey for her travel tips (hit Singapore's dreamy flower hub), beauty musings ("they call me sassy pants"), and latest obsessions (Madewell is everything!). She lives with her college-sweetheart husband and two ginger cats in sunny Costa Mesa, California.

Photograph © Michael Radford

INDEX

A

Agapanthus, 148–52
analogous palettes, 22
Anemone, 46–51
anther, 31
Arundina Orchid, 160–62

B

balance, creating, 25
Bearded Iris, 164–68
bell-shaped flowers, 88
 English Bluebell, 94–96
 Foxglove, 98–102
 Parrot Tulip, 90–92
 Penstemon, 104–8
bends, 29, 30
blacks, 20
Bluebell, English, 94–96
blues, 17
bowl-shaped flowers, 110
 Camellia, 112–14
 Chrysanthemum, 116–18
 Hellebore, 120–24
 Peony, 126–30
browns, 19
brushes
 cleaning, 11
 compound strokes with, 34–35
 hair of, 11
 holding, 34
 quality of, 10
 shape of, 10–11
 storing, 11
 tips for, 11–12
 traveling with, 11–12

C

Camellia, 112–14
C curves, 29, 34
Cherry Blossom, 40–44
Chrysanthemum, 116–18
circle-shaped flowers, 64
 Dahlia Scura, 72–74
 Eden Rose, 82–86
 Ranunculus, 76–80
 Sunflower, 66–70

Clematis, 52–56
cold-pressed paper (CP), 8
color lifting, 9–10, 33
colors
 complementary, 14, 24
 cool, 14
 harmony and, 177
 hue, 20
 lightening, 15–16
 list of, 5
 mixing, 12, 15–16
 primary, 13
 saturation/desaturation or shade, 20
 secondary, 13
 tertiary, 14
 tone, 20
 warm, 14
 See also palettes; value; individual
 colors
color wheel, 13–14
combination shape, 154
 Arundina Orchid, 160–62
 Bearded Iris, 164–68
 Coneflower, 170–74
 Sweet Pea, 156–58
complementary colors, 14, 24
composition, 25, 27
compound strokes, 34–35
Coneflower, 170–74
cool colors, 14
curves, 29, 30, 34

D

dabbing, 33
Dahlia Scura, 72–74
desaturation, 20

E

Echinacea Flower, 170–74
Eden Rose, 82–86
English Bluebell, 94–96
eye-shaped leaves, 36

F

filament, 31
flowers
 anatomy of, 31
 shapes of, 27–28
 See also individual flowers

focal points, 25
foreshortening, 29
Foxglove, 98–102

G

gouache, 7, 33

H

heart-shaped leaves, 36
Hellebore, 120–24
highlighting, 33
hot-pressed paper (HP), 8
hue, 20

I

Iris, Bearded, 164–68

L

leaf shapes, 35–37. See also
 individual flowers
loose-style pieces
 Anemone, 46–51
 Arundina Orchid, 160–62
 Camellia, 112–14
 Cherry Blossom, 40–44
 Chrysanthemum, 116–18
 Dahlia Scura, 72–74
 English Bluebell, 94–96
 final project, 177–78
 Nasturtium, 134–36
 Parrot Tulip, 90–92
 Stargazer Lily, 138–40
 Sunflower, 66–70
 Sweet Pea, 156–58
 tips for, 177

M

masking fluid, 7
mistakes, 3, 180
monochromatic palettes, 22
Morning Glory, 142–46
movement, creating, 25, 177

N

Nasturtium, 134–36
negative space, 27

O

observation, 180
oranges, 18
Orchid, 58–62
 Arundina, 160–62
oval-shaped leaves, 37
ovary, 31

P

paint
 buying, 4–5
 grainy, 7
 quality of, 4
 tips for, 7
 See also palettes
palettes
 color list for, 5
 setting up, 7
 traveler's, 12
 types of, 12, 22–24
 using, for the first time, 12
paper
 acid-free, 10
 blocks of, 9
 color lifting and, 9–10
 cotton, 10
 as loose sheets, 9
 pads of, 9
 practice, 10
 stretching, 9
 textures of, 8
 thicknesses/weights of, 8–9
 tips for, 9–10
Parrot Tulip, 90–92
pencils, 13
Penstemon, 104–8
Peony, 126–30
petals
 in anatomical painting, 31
 connecting stem to, 49
 See also individual flowers
pinks, 18
pin-shaped leaves, 35
practice
 importance of, 3, 178
 paper for, 10
primary colors, 13
purples, 19

R

Ranunculus, 76–80
realistic-style pieces
 Agapanthus, 148–52
 Bearded Iris, 164–68
 Clematis, 52–56
 Coneflower, 170–74
 Eden Rose, 82–86
 Foxglove, 98–102
 Hellebore, 120–24
 Morning Glory, 142–46
 Orchid, 58–62
 Penstemon, 104–8
 Peony, 126–30
 Ranunculus, 76–80
receptacle, 31
reds, 17
reference materials, 25, 28
Rose, Eden, 82–86
rough paper, 8
Rule of Thirds, 25

S

salt, 7
saturation, 20
scratching, 33
S curves, 29, 34
secondary colors, 13
sepal, 31
shade, 20
shapes, basic, 27–28
sketching
 basics of, 27–29
 reference materials for, 28
 tonal, 30
split-complementary palettes, 24
stamen, 31
Stargazer Lily, 138–40
star-shaped flowers, 38
 Anemone, 46–51
 Cherry Blossom, 40–44
 Clematis, 52–56
 Orchid, 58–62
stems
 in anatomical painting, 31
 connecting to petals, 49
 See also individual flowers
stigma, 31
Sunflower, 66–70
Sweet Pea, 156–58

T

techniques, 32–35
tertiary colors, 14
textures
 creating, 33
 of paper, 8
Thirds, Rule of, 25
tonal sketching, 30
tone
 changing, 37
 definition of, 20, 30
trumpet-shaped flowers, 132
 Agapanthus, 148–52
 Morning Glory, 142–46
 Nasturtium, 134–36
 Stargazer Lily, 138–40
Tulip, Parrot, 90–92

V

value
 definition of, 20
 scales, 15–16, 22

W

warm colors, 14
water
 amount of, on brush, 15
 containers, 12
wet-on-dry technique, 33
wet-on-wet technique, 32, 42

Y

yellows, 18

Published in the United States by Watson-Guptill Publications, an imprint
of the Crown Publishing Group, a division of Penguin Random House LLC,
New York.
www.crownpublishing.com
www.watsonguptill.com

WATSON-GUPTILL and the HORSE HEAD colophon are registered
trademarks of Penguin Random House LLC.

Library of Congress Cataloging-in-Publication Data

Names: Rainey, Jenna, 1989- author.
Title: Everyday watercolor flowers : a modern guide to painting blooms,
 leaves, and stems step by step / Jenna Rainey.
Description: First edition. | California : Watson-Guptill, [2019] | Includes
 bibliographical references and index. |
Identifiers: LCCN 2018057552 (print) | LCCN 2018058052 (ebook)
Subjects: LCSH: Flowers in art. | Watercolor painting—Technique. | BISAC:
 ART / Techniques / Watercolor Painting. | ART / Subjects & Themes /
 Plants & Animals. | CRAFTS & HOBBIES / Painting.
Classification: LCC ND2244 (ebook) | LCC ND2244 .R35 2019 (print) |
 DDC 704.9/4343—dc23
LC record available at https://lccn.loc.gov/2018057552

Trade Paperback ISBN: 978-0-399-58221-9
eBook ISBN: 978-0-399-58220-6

Printed in China

Design by Annie Marino

10 9 8 7 6 5 4 3 2 1

First Edition